KU-315-761

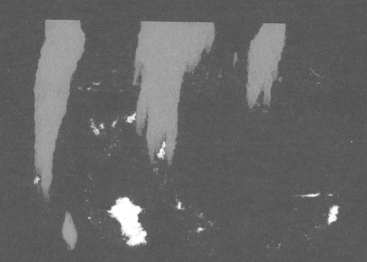

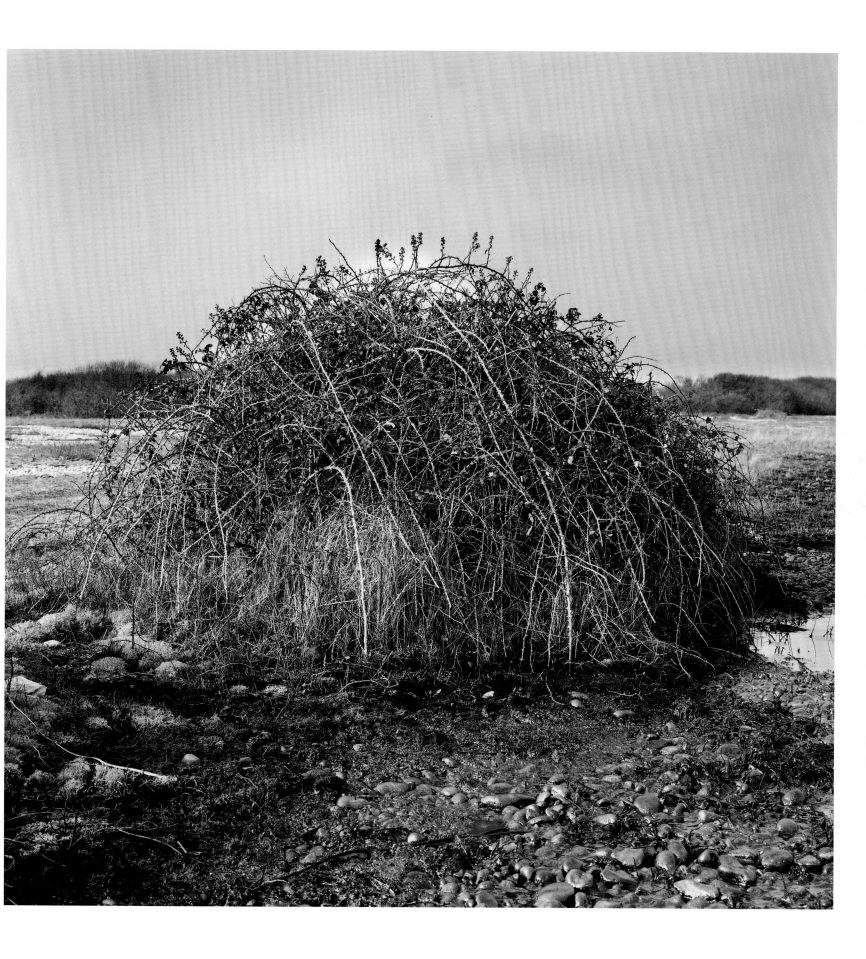

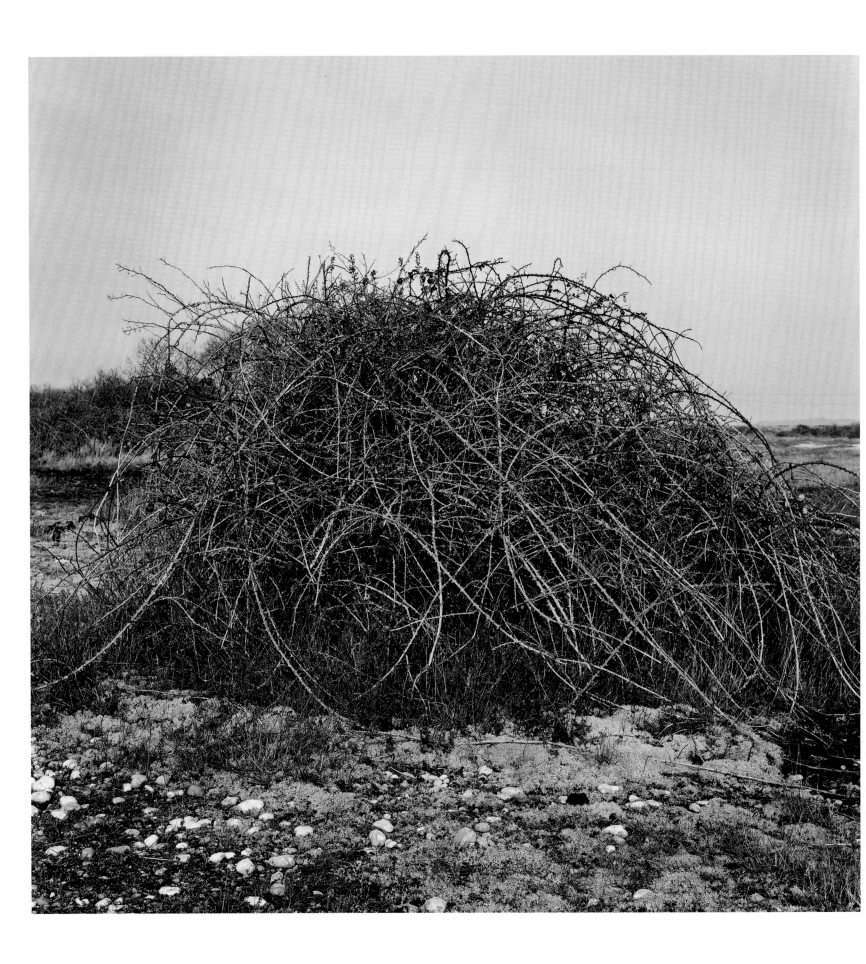

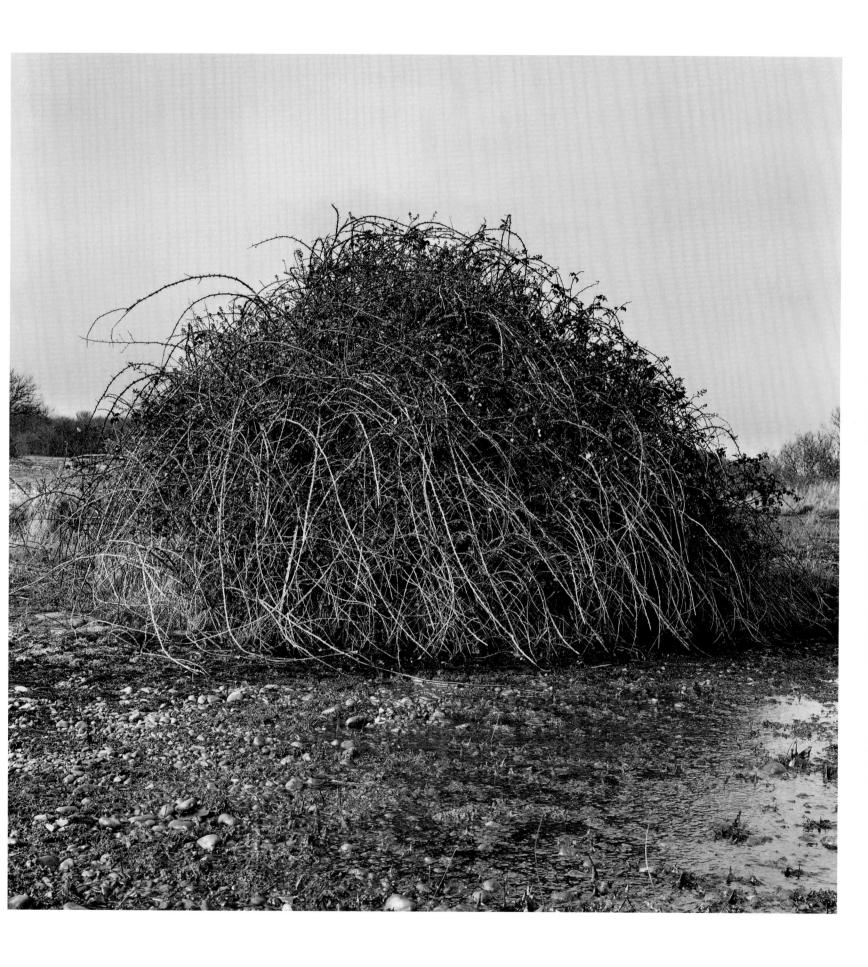

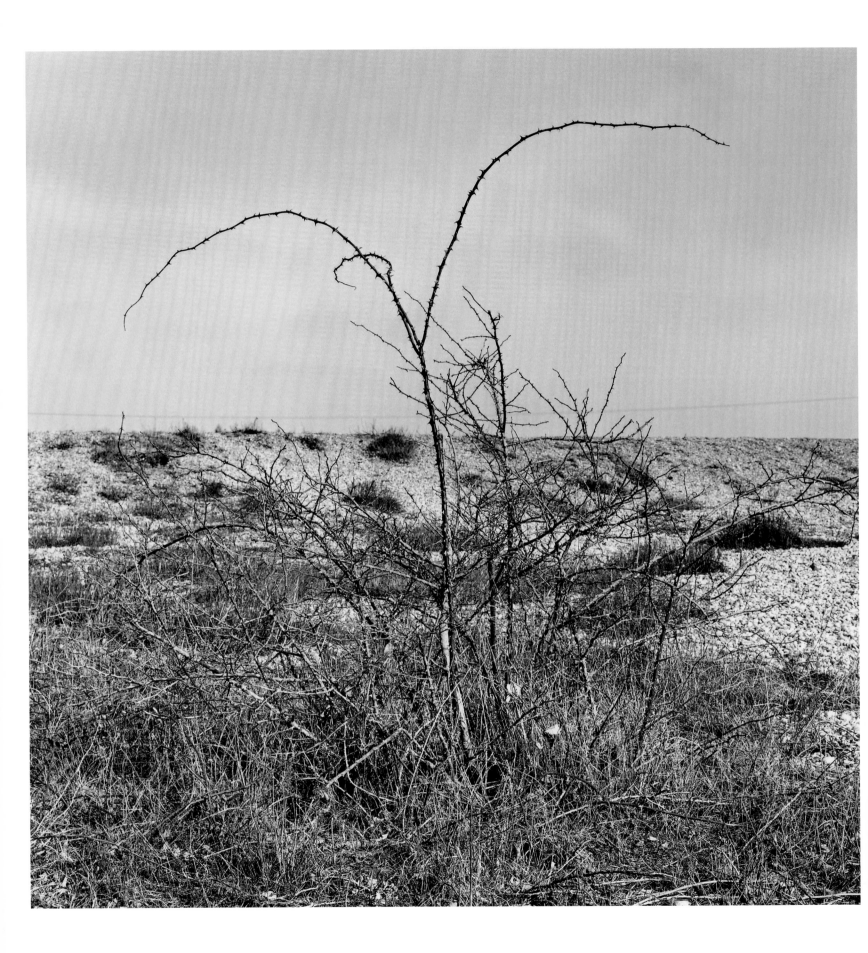

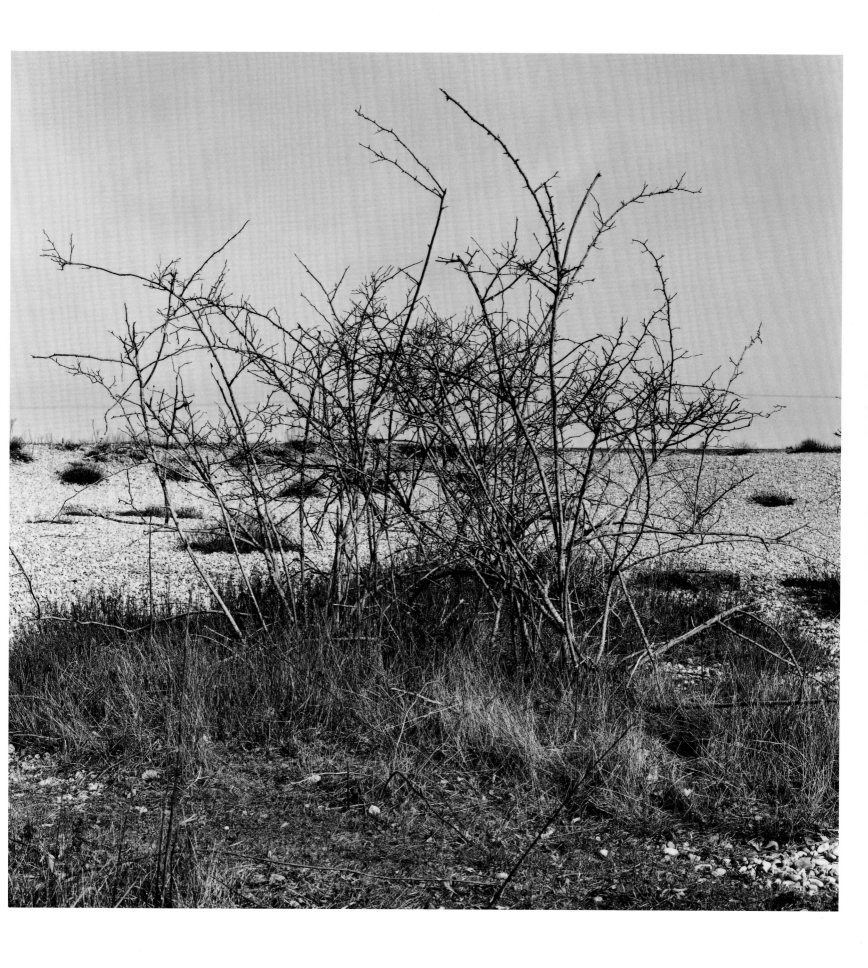

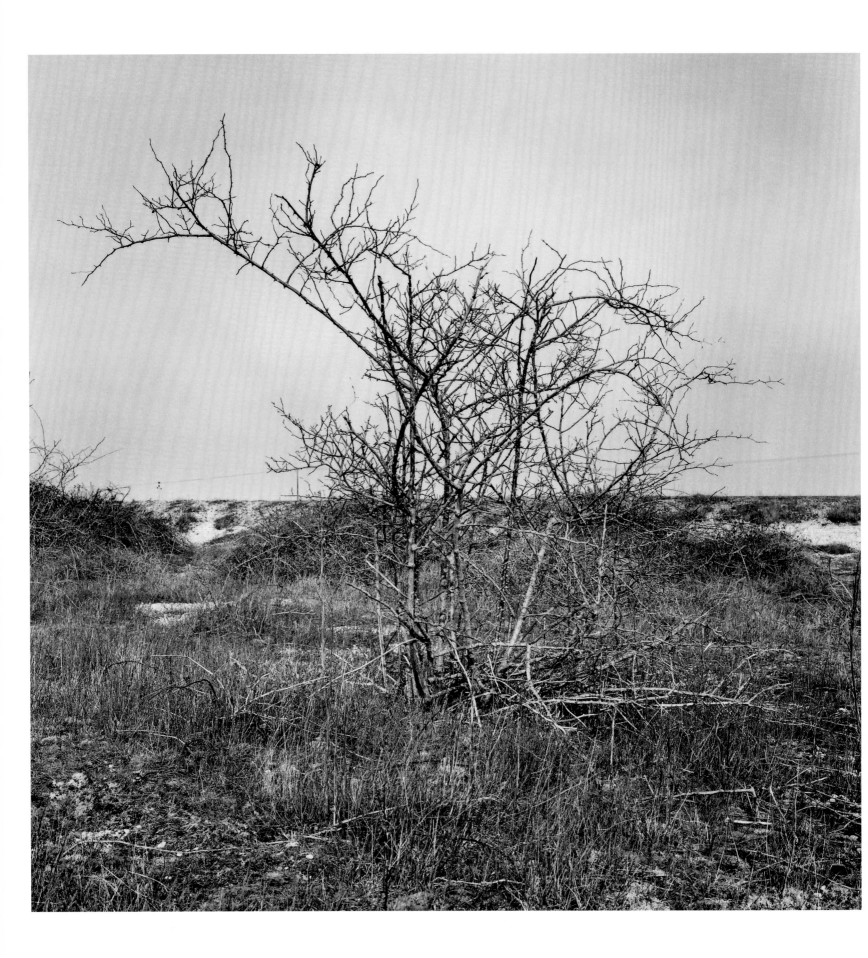

DUNGENESS NIGEL GREEN

photoworks

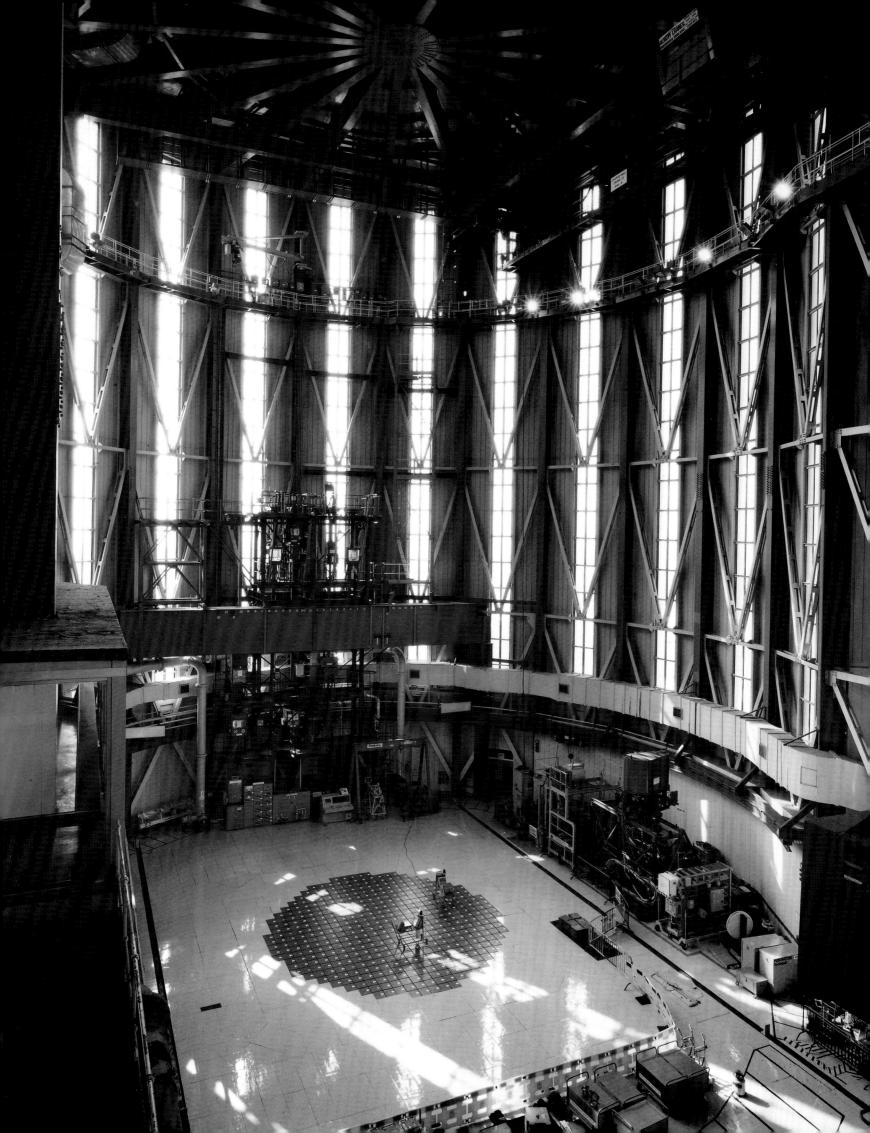

FOREWORD AND ACKNOWLEDGEMENTS

Dungeness is one of the most extraordinary places on the British coastline. With its two nuclear power stations rising from a shingle headland of seventy-two square kilometres, with its small community of fisherman's huts, bungalows and houses, and its sparse but resilient vegetation, this remote, windswept landscape is a place of strange contrasts and juxtapositions of scale. During 2002 and 2003, Dungeness became the focus of an ambitious Photoworks project, one that continued our commitment to commissioning new photographic work in relation to specific and distinctive sites throughout the South East of England. Following an exhibition at the Sassoon Gallery in Folkestone in the summer of 2003 and its associated education programme, this book is the culmination of that project.

At the heart of both project and book is the remarkable photographic work of Nigel Green. Building on his connections with Dungeness that go back to the 1960s, Photoworks approached Green in 2001 to suggest that he might, finally, take stock of those connections and develop a new body of work in response to the place. For his subsequent Photoworks commission, Green chose to focus on the power stations themselves, developing a substantial, yet ambiguous series of works that consider both the formal grandeur of the site, with all its modernist resonances, and the alchemical mystery that makes the place so compelling.

Green's work, the project surrounding it and now this book, offer a range of new perspectives on Dungeness and its unique sense of place. All have been built around the participation of a wide range of people – artists, writers, educators, students, school children and local people – and through this Photoworks has encouraged the interest and engagement of an even wider audience.

Photoworks would like to extend its gratitude to all those who have contributed their valuable time, help and expertise to this project over the last few years. In particular we would like to thank Martin Pearce, formerly of British Energy, whose initial enthusiasm and assistance, gave the project a much needed foothold at Dungeness 'B' Station; Liz Kent, for organising the project's education programme with such commitment and imagination; Jonathan Glancey for creating such a lively and well-rounded 'guide' to Dungeness for this book; Stuart Smith for his continuing advice and excellent design; the exhibition installation team of Sebastian Pedley, Marcus Haydock, Ben Burbridge, Georgia Chandler and Jack Reynolds, for all their hard work in difficult conditions; Spectrum Photographic for their superb printing of the exhibition and book prints; Andrew Chilton for the exquisite exhibition frames; Melanie Blatchley of Folkestone Library, and Arts Council England for their support and vital financial assistance. Lastly we would like to offer our sincere thanks to Nigel Green, who has shown great intelligence, sensitivity and good humour while working so hard throughout the duration of this project.

DAVID CHANDLER
Director, Photoworks

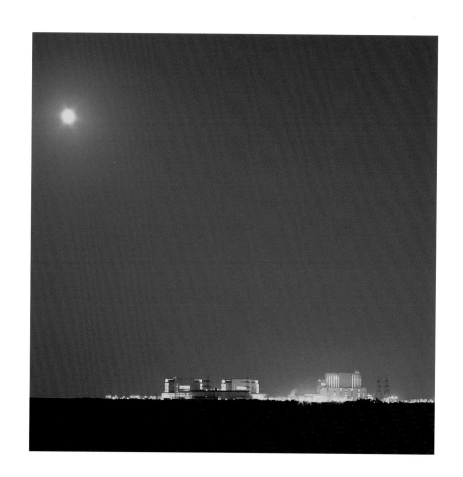

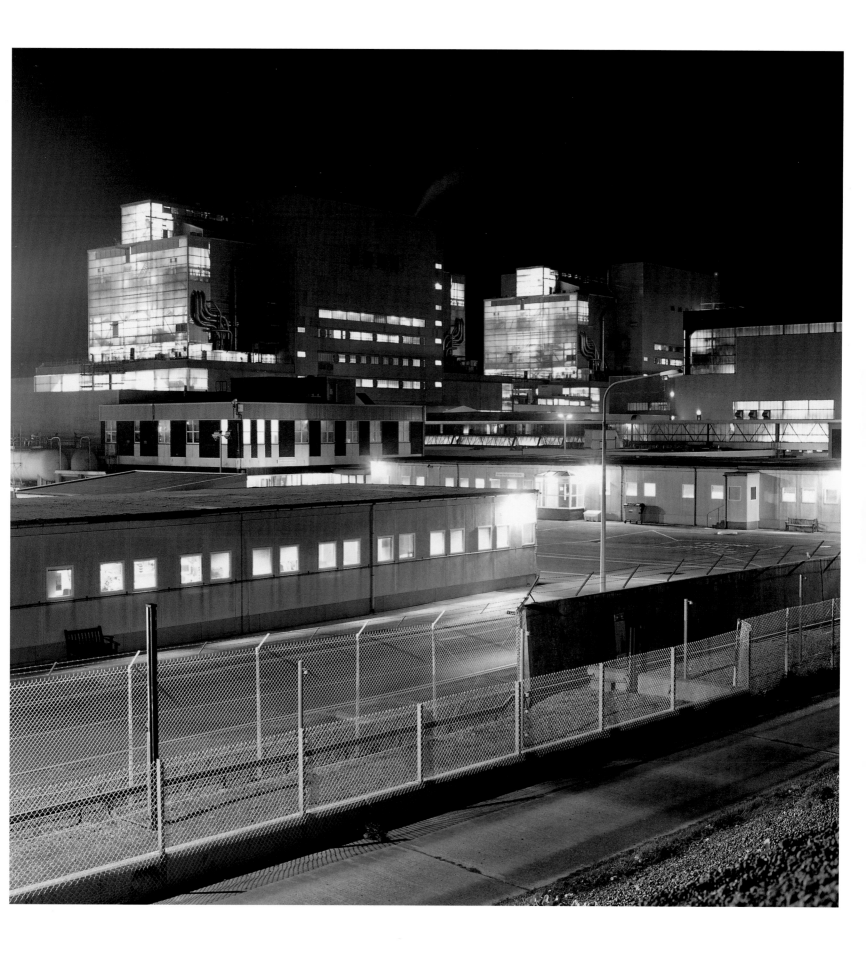

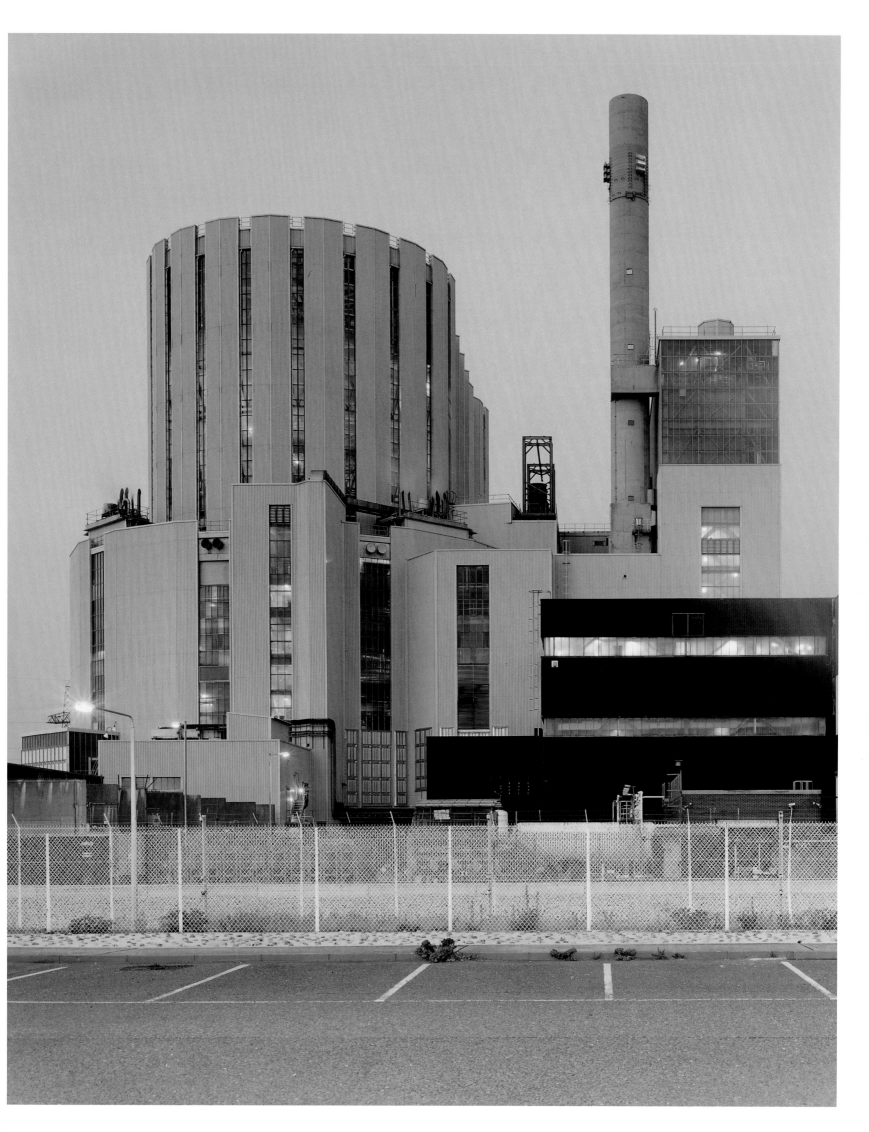

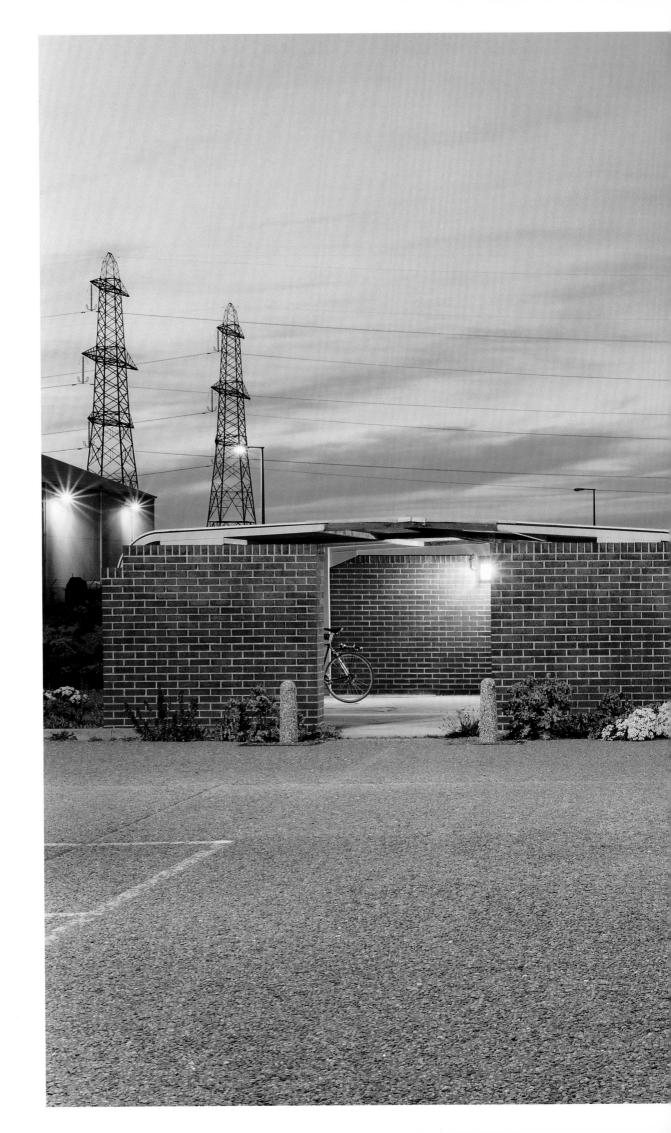

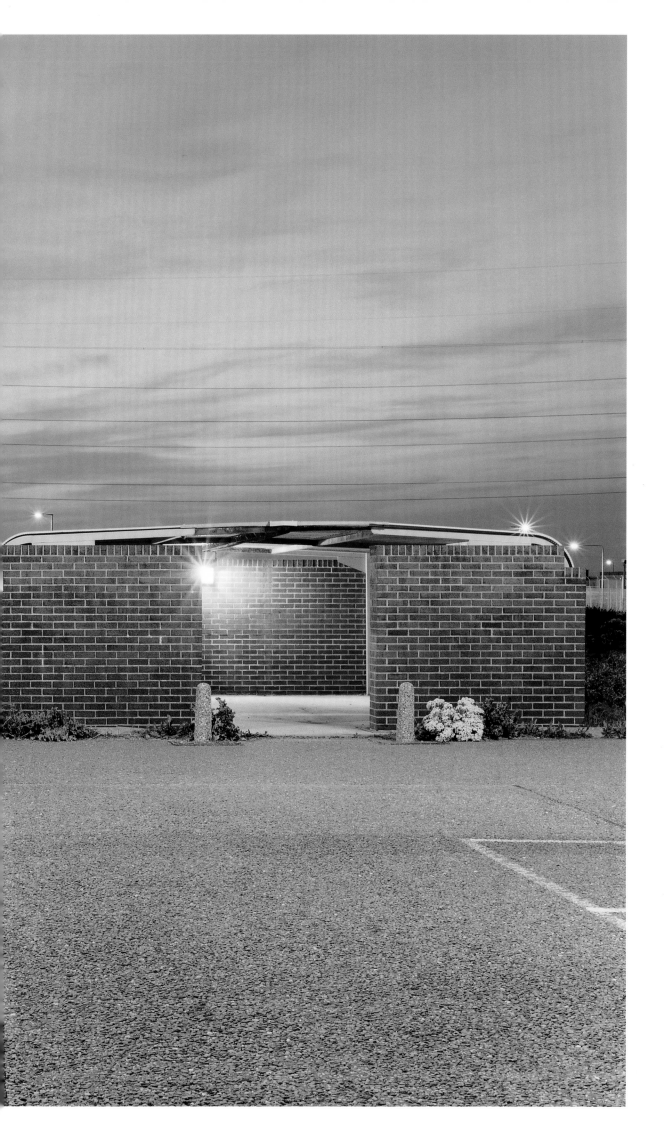

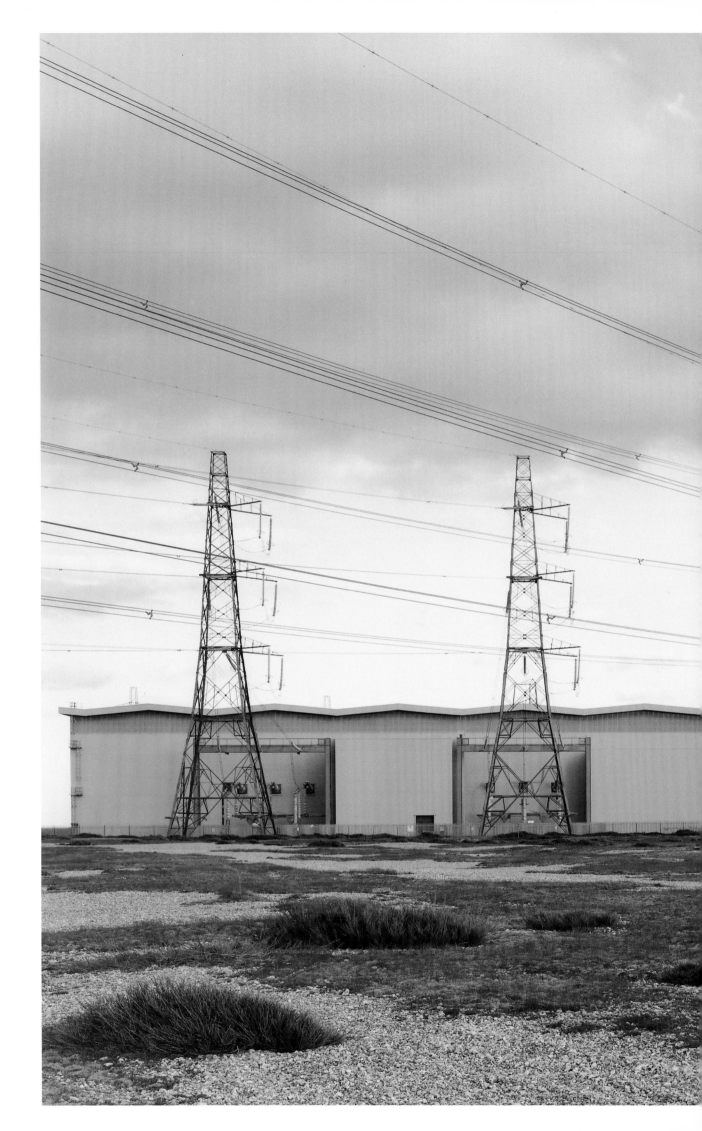

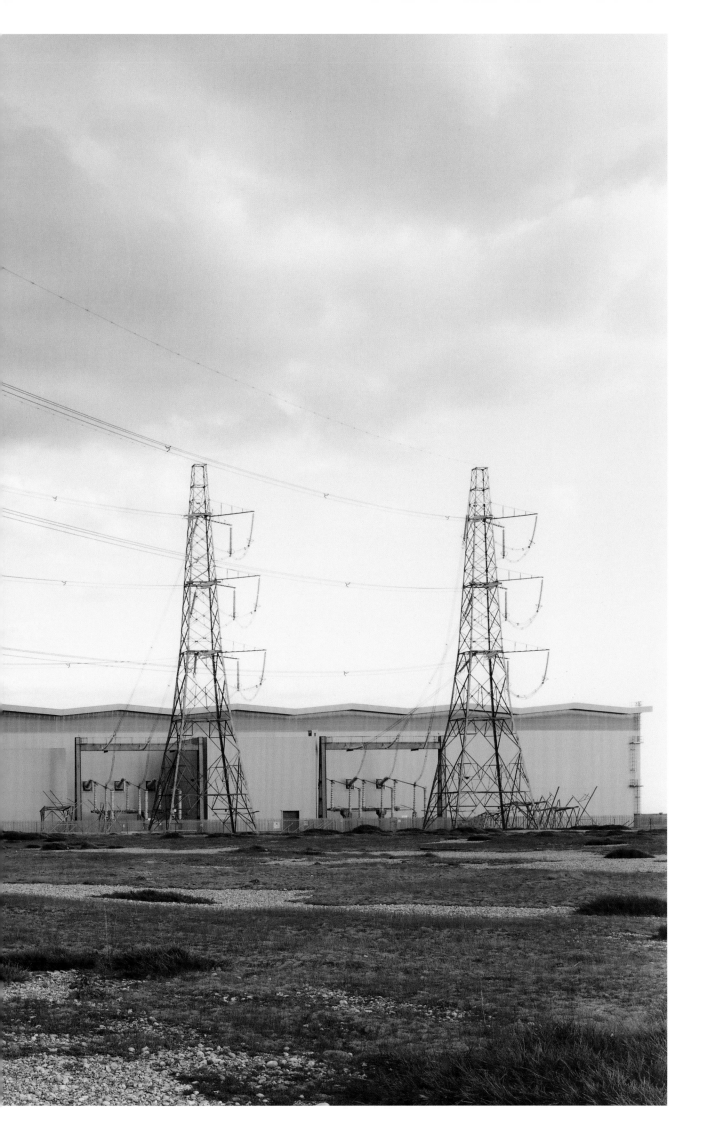

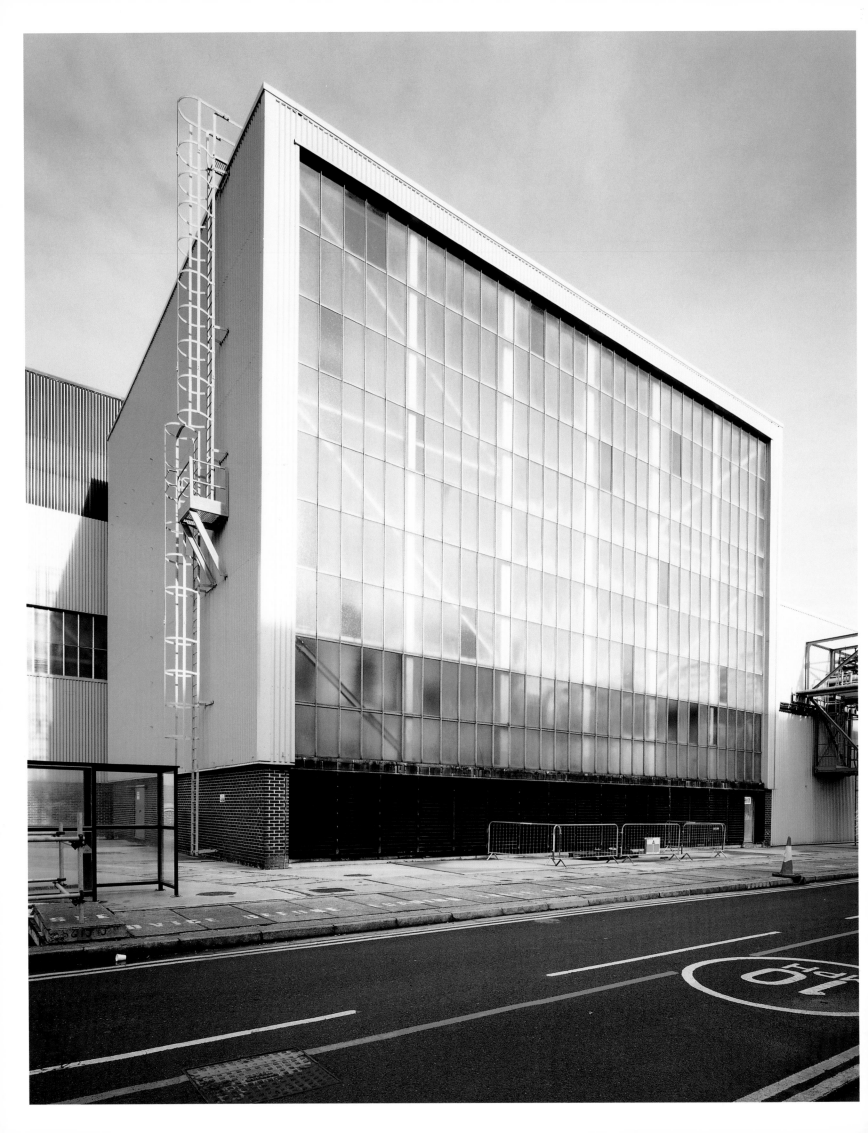

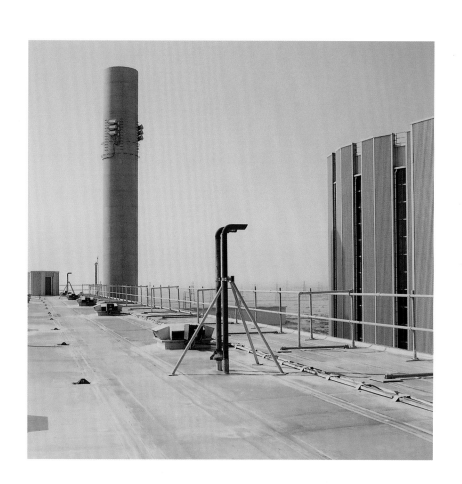

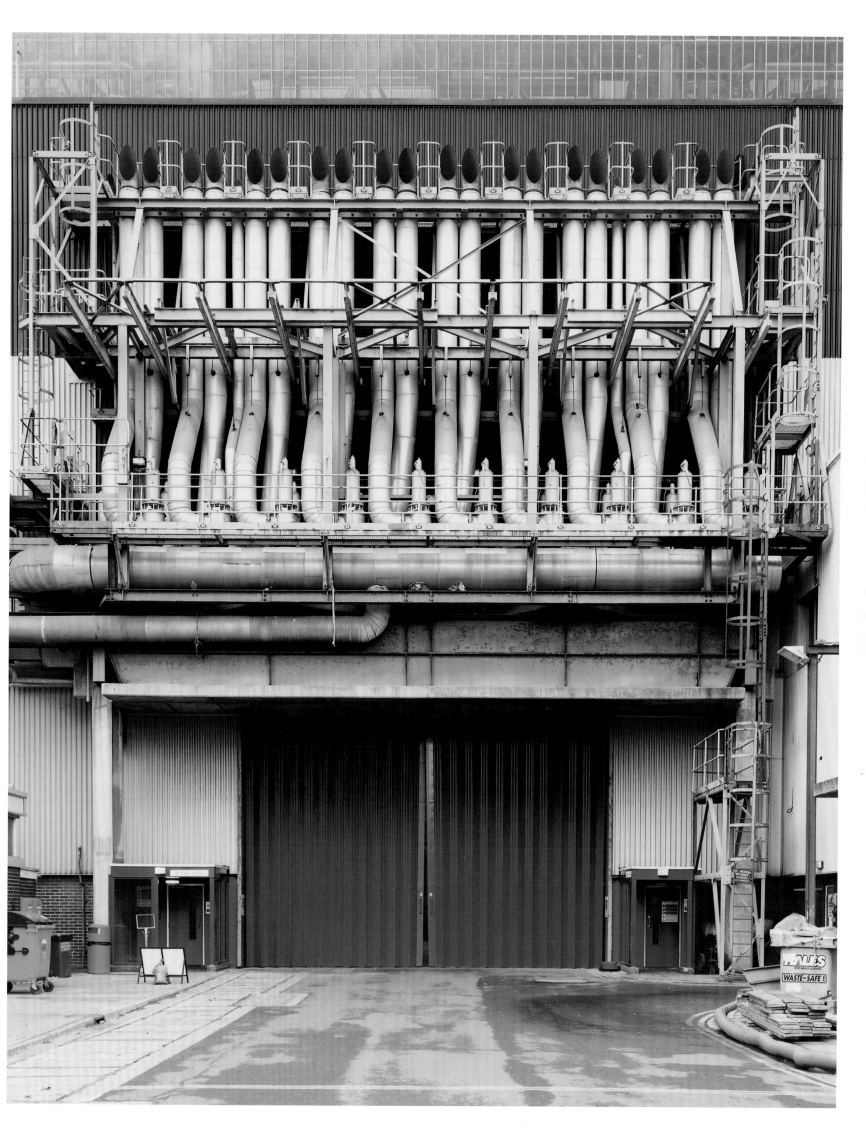

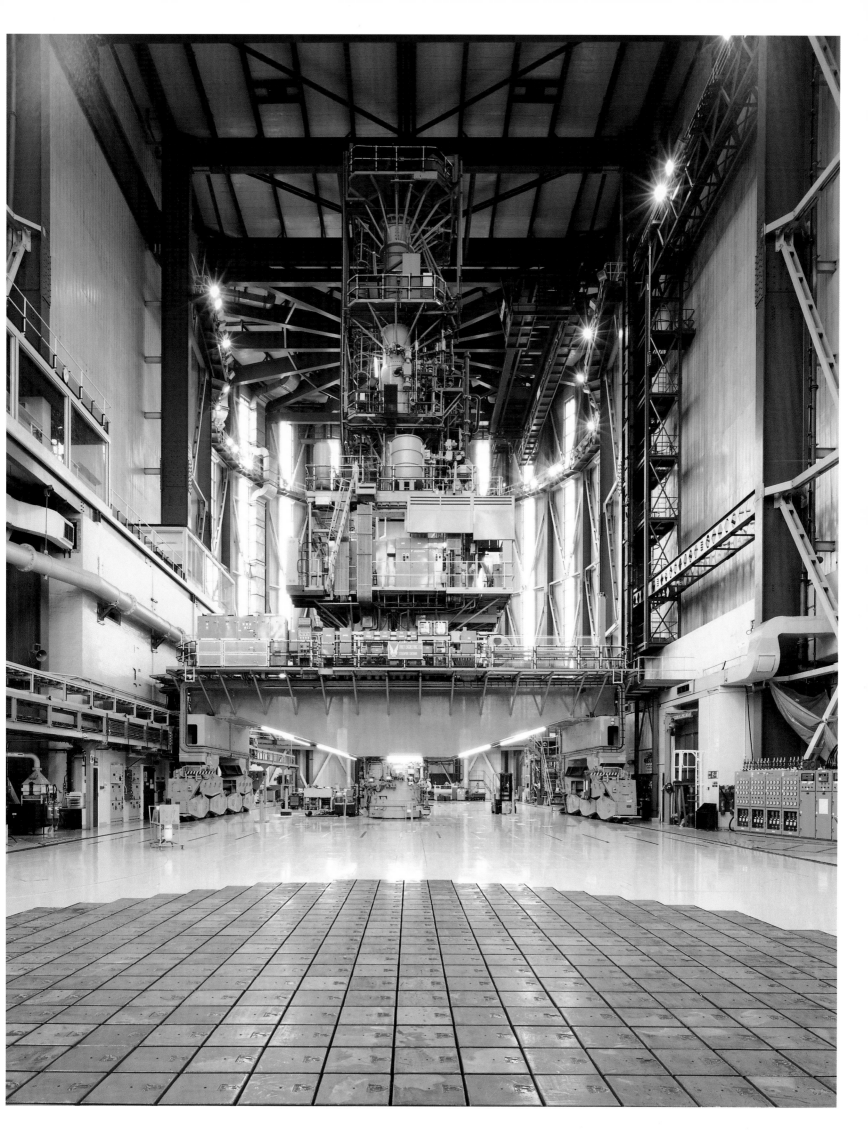

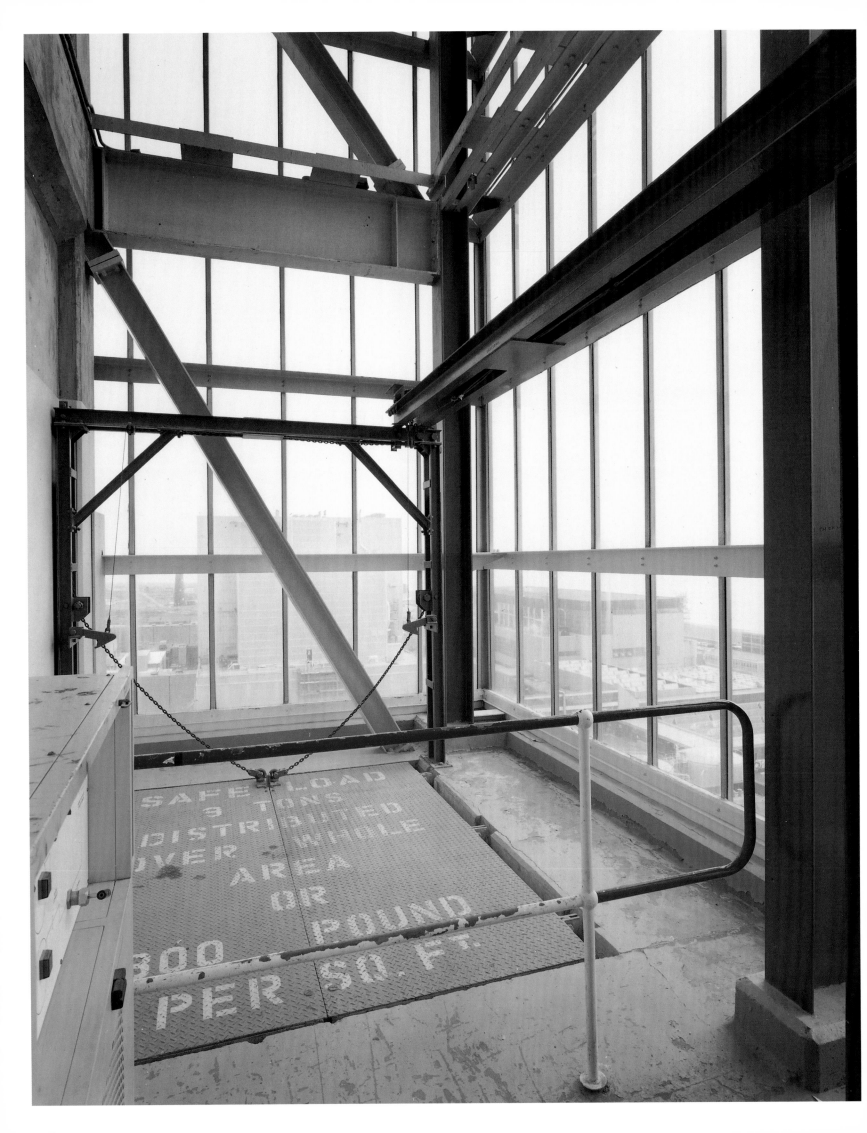

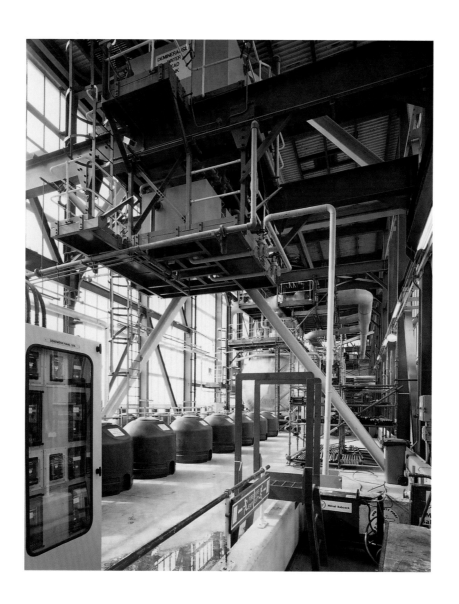

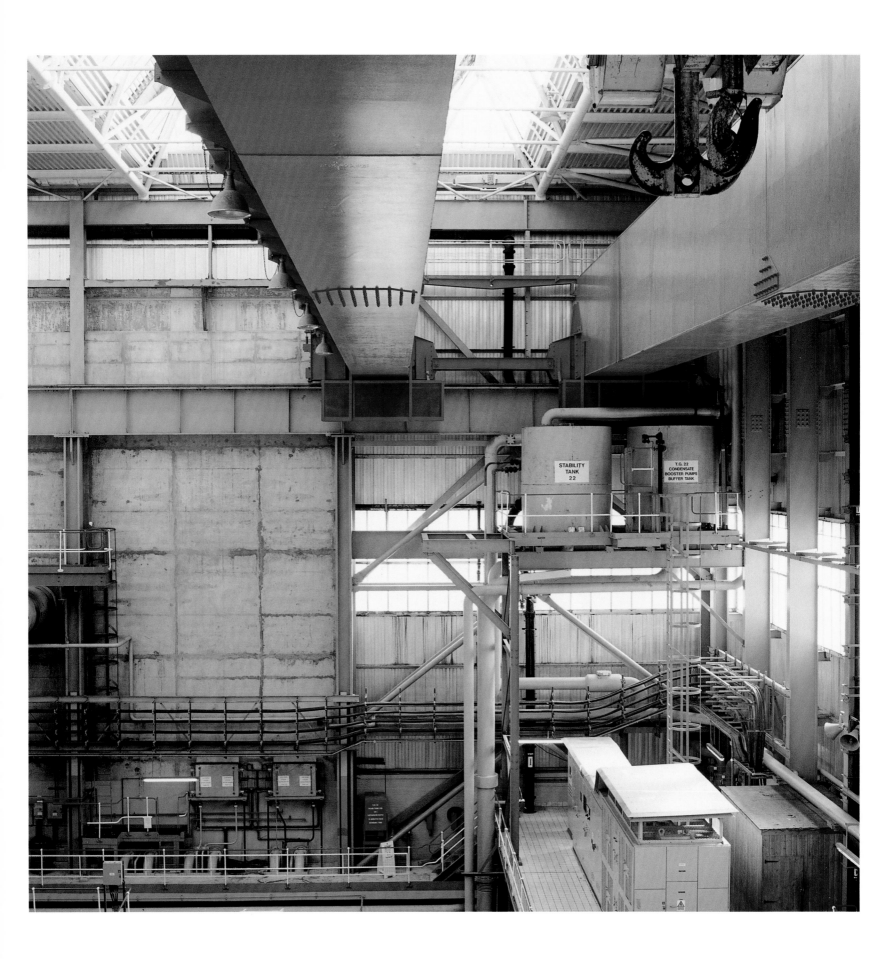

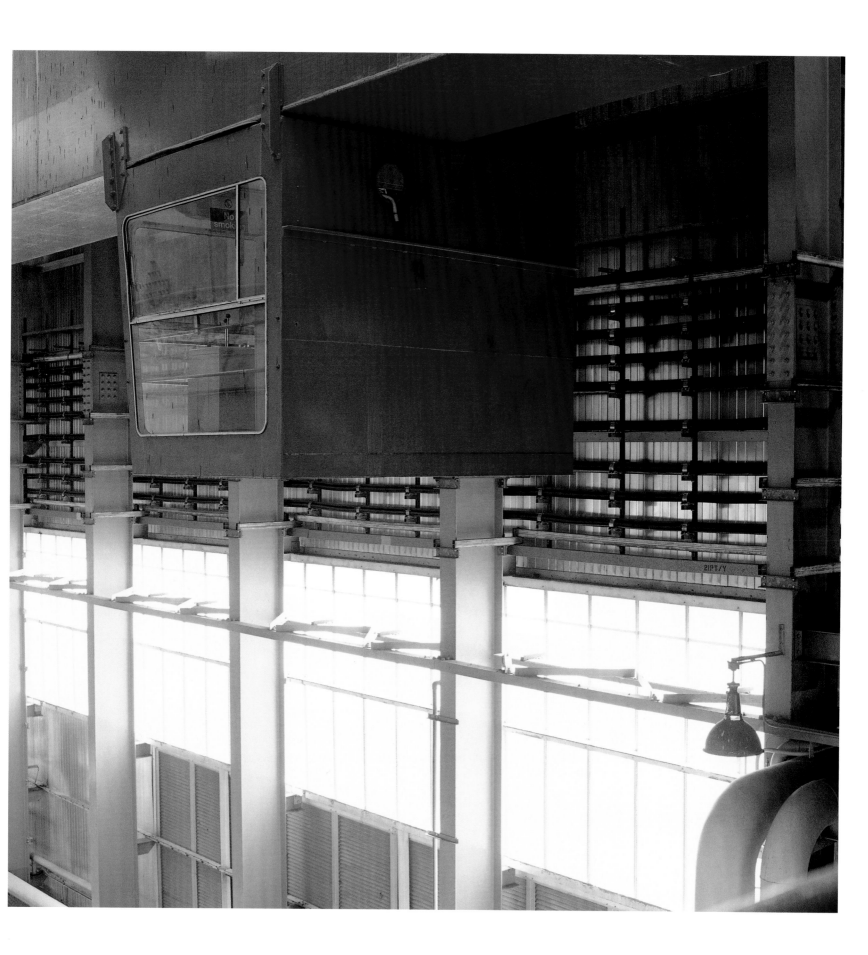

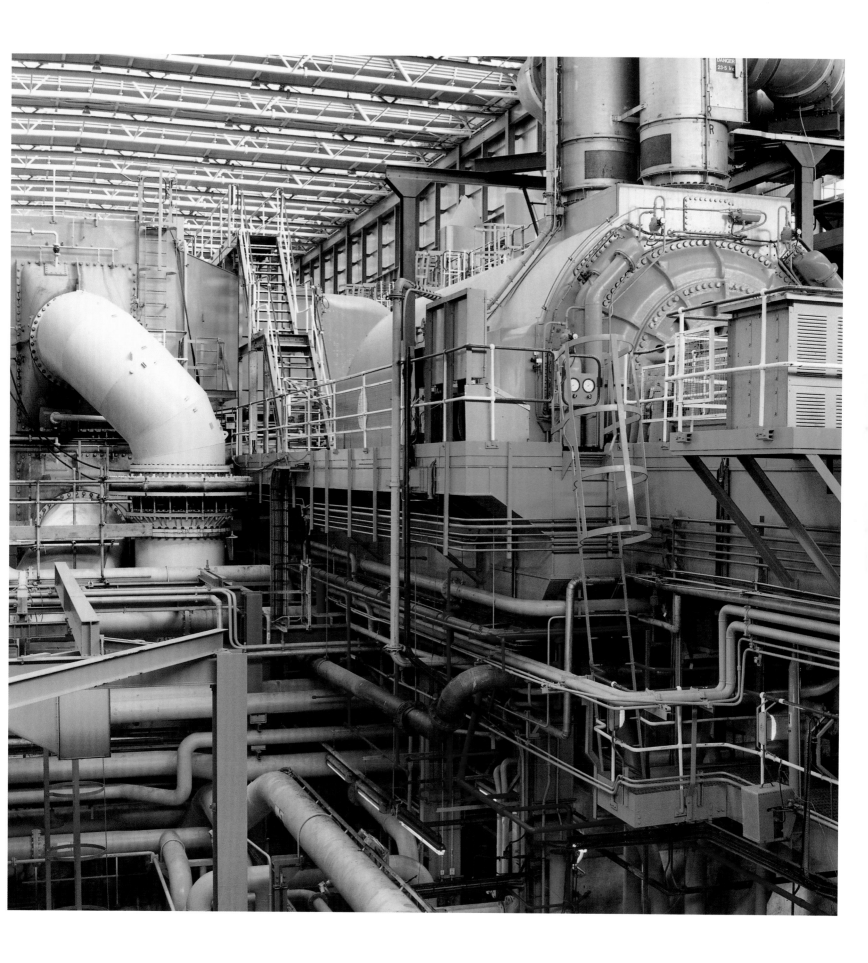

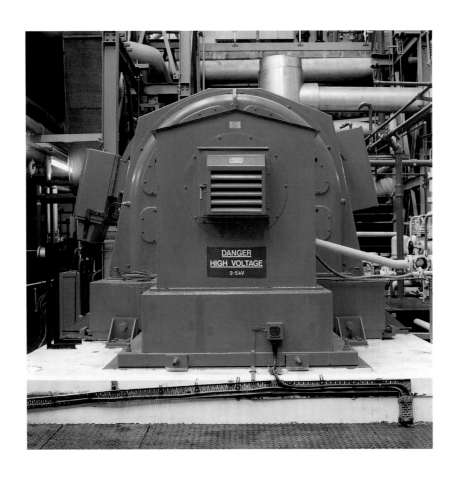

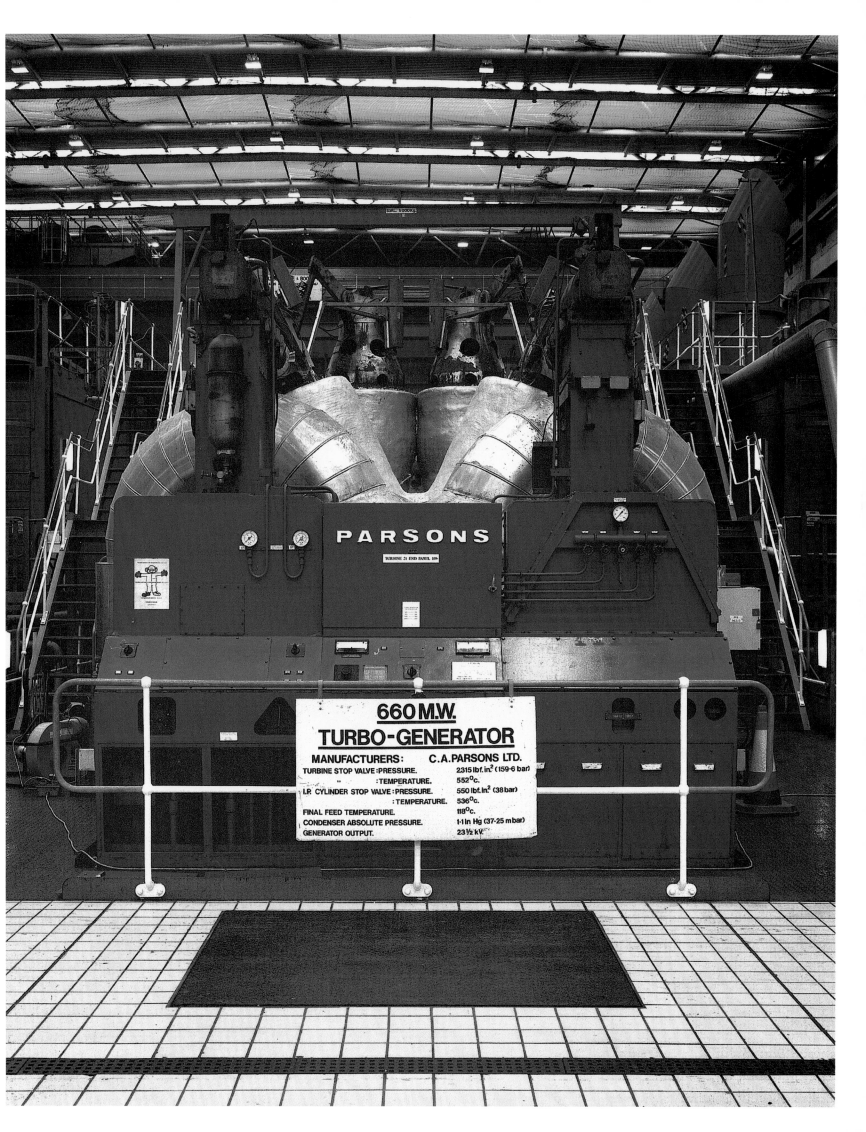

PARSONS

TURBINE 21 END PANEL 109

660 M.W.
TURBO-GENERATOR

MANUFACTURERS:	C.A.PARSONS LTD.
TURBINE STOP VALVE : PRESSURE.	2315 lbf. in.2 (159·6 bar)
" : TEMPERATURE.	552°C.
I.P. CYLINDER STOP VALVE : PRESSURE.	550 lbf. in.2 (38 bar)
: TEMPERATURE.	536°C.
FINAL FEED TEMPERATURE.	118°C.
CONDENSER ABSOLUTE PRESSURE.	1·1 In Hg (37·25 m bar)
GENERATOR OUTPUT.	23½ kV.

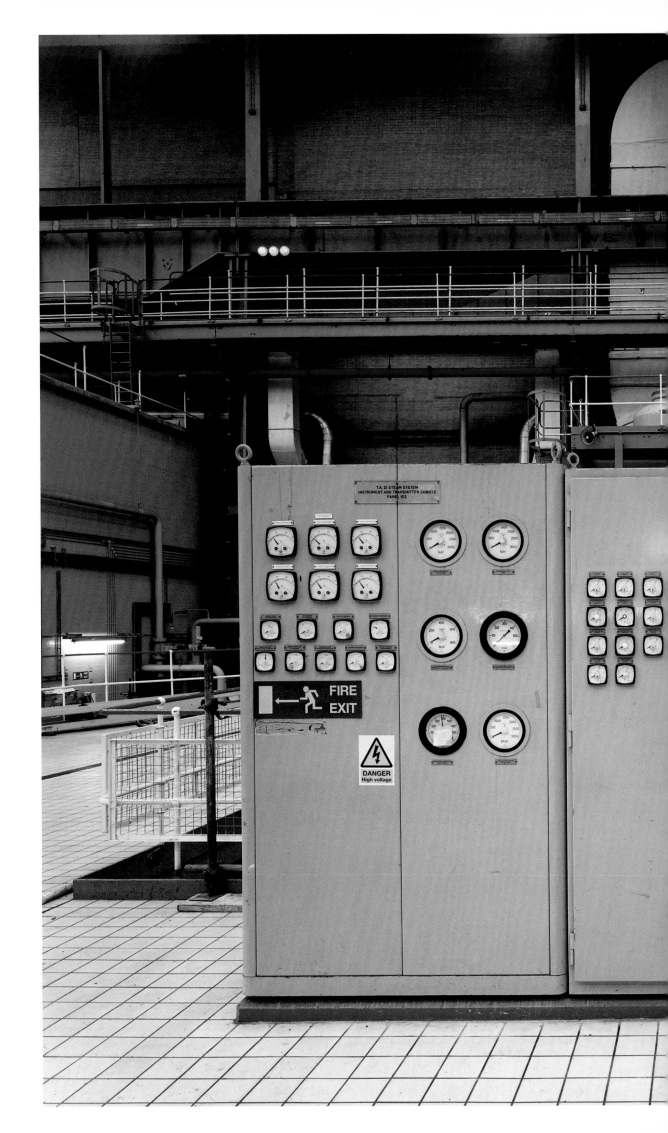

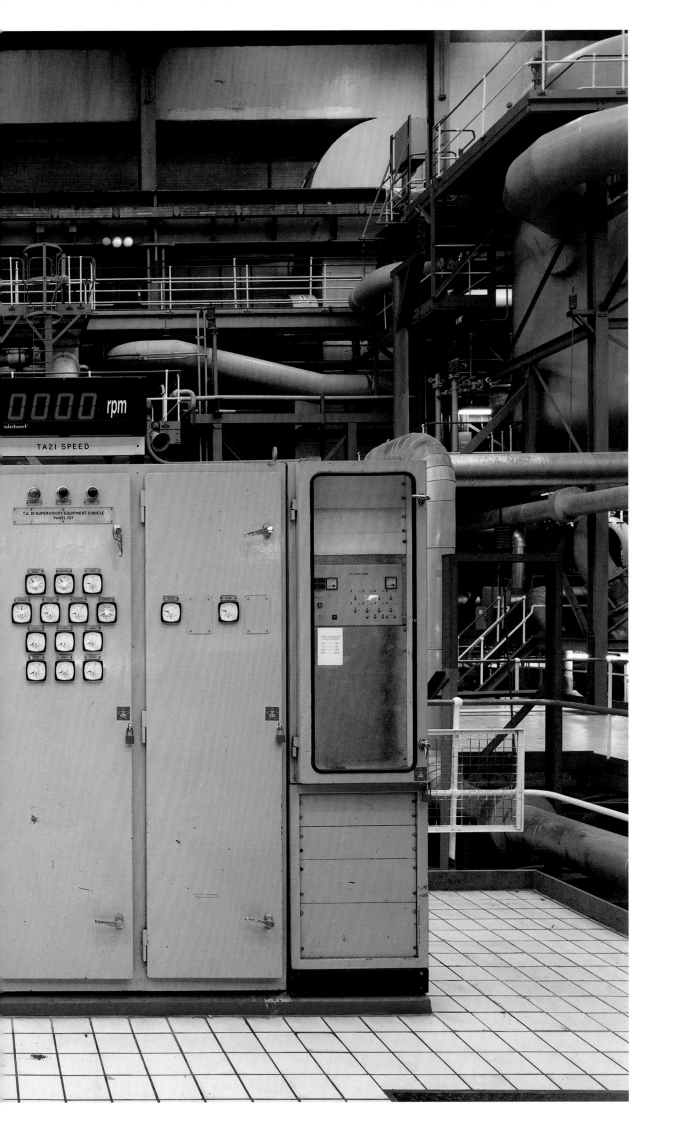

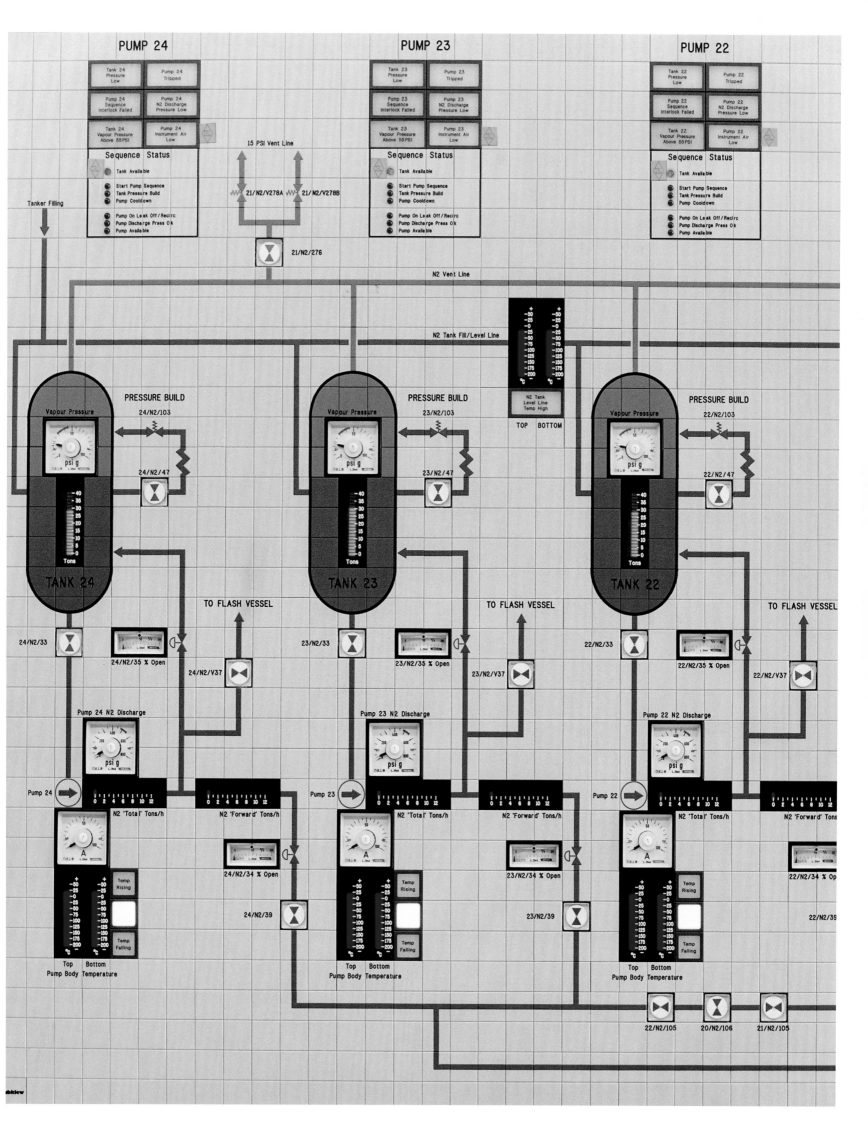

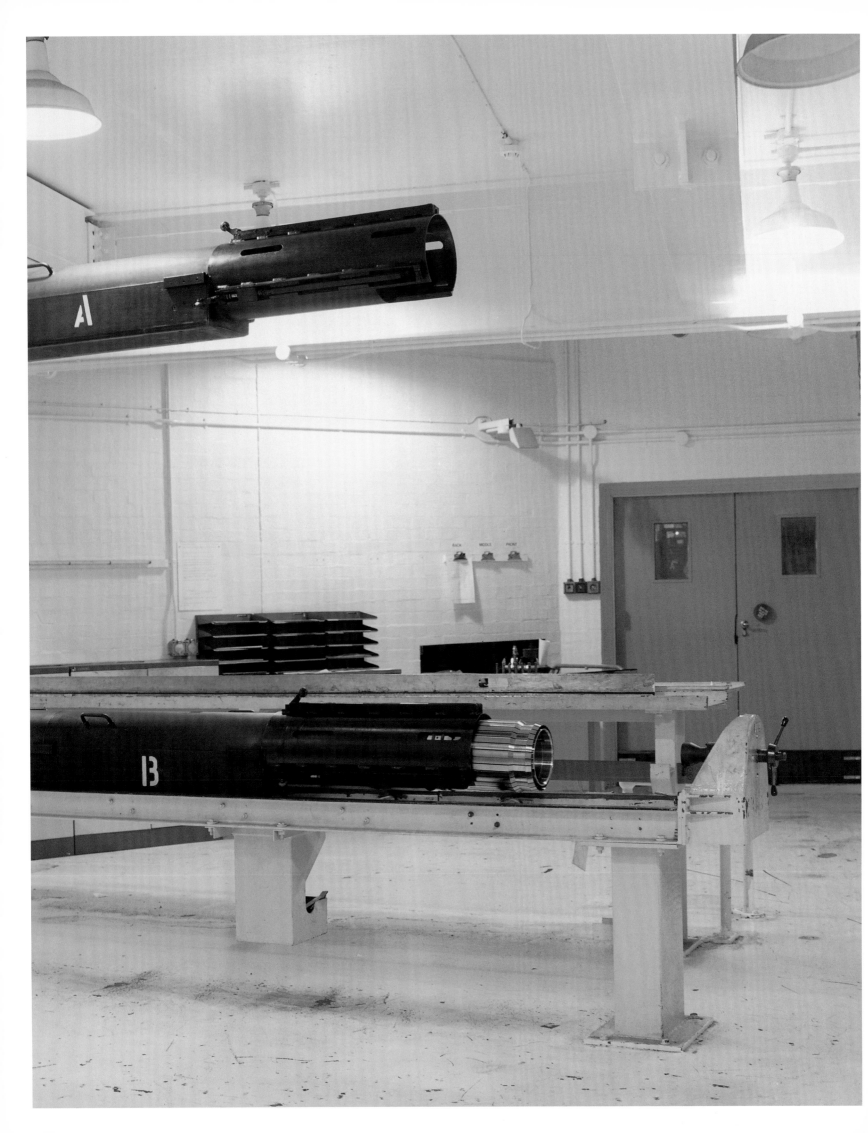

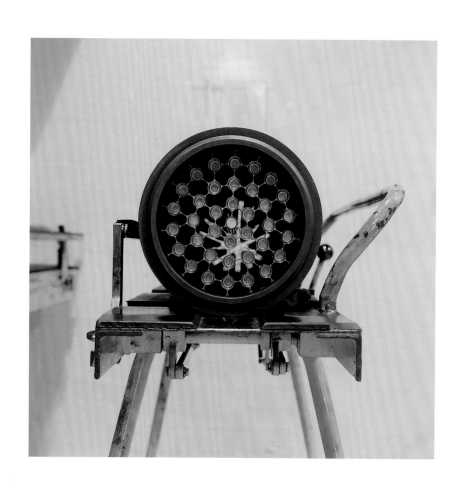

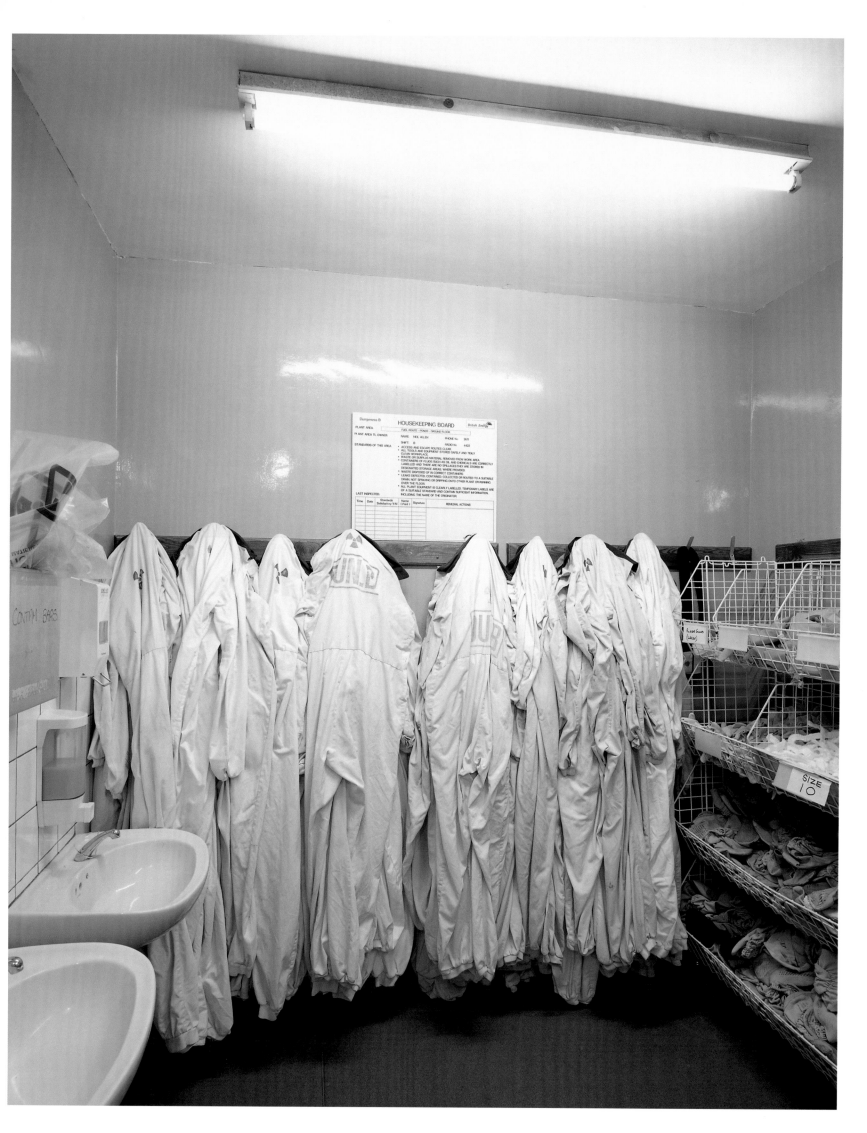

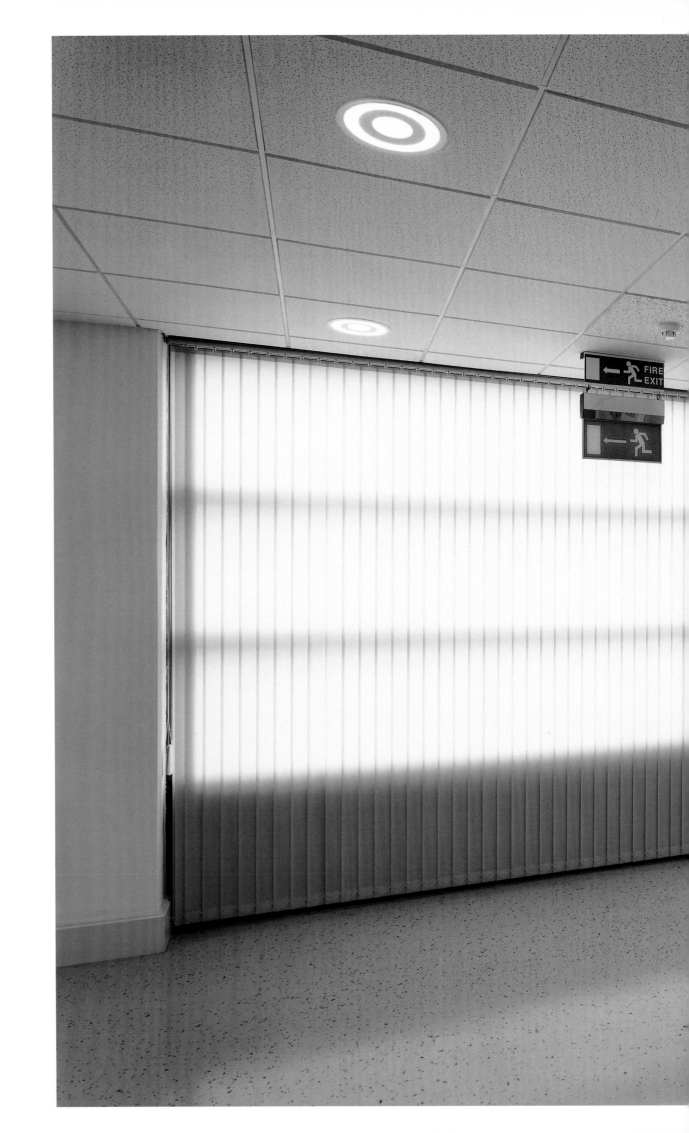

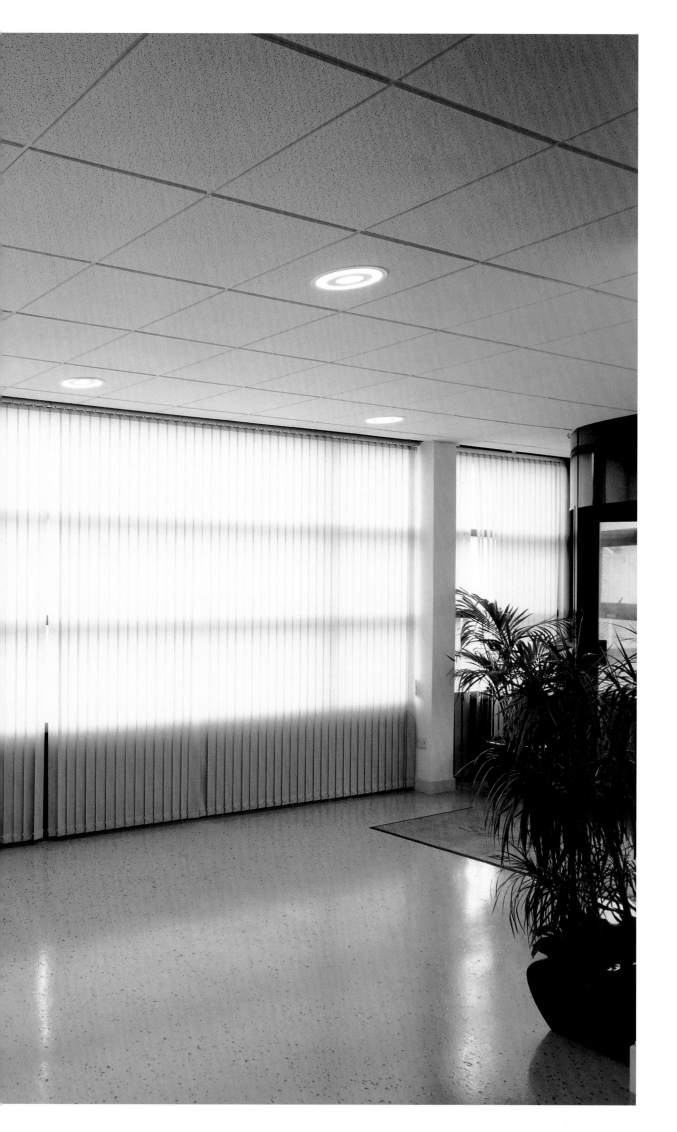

SECOND NATURE: NIGEL GREEN AT DUNGENESS
DAVID CHANDLER

To drive through Winchelsea and then Rye on the A259 towards Folkestone is to leave behind the rolling, green downland of East Sussex and enter an altogether different landscape. Emerging from Rye, the land quickly becomes flat, space stretches out, vertical forms are more isolated and strange, trees and buildings are now silhouetted against the sky; the environment has become less inviting and a windswept terrain of plain fields empties out before you for miles. One feature begins to dominate this landscape, and characterise its severe angularity: chains of electricity pylons trail across the open space converging towards some unseen point beyond the horizon. The pylons' diminishing perspective emphasises the sense that they seem to be drawn to this point, and creates the feeling that you, too, are being pulled inexorably into this place hidden from sight. That place, first revealed as a grey-blue shadow on the horizon, is Dungeness, or more specifically the huge industrial complex that contains the two nuclear power stations built there in the 1960s and 70s. The landscape, and the logic of the pylons begins to clarify around this view, but there is still a feeling of being pulled in, that the electricity is being drawn inward rather than dispersed outward, and that the emptiness of the land is also somehow a result of this process of absorption. In fact it is difficult to imagine this bleak landscape now without the power stations. They have created an end point, a mark of focus across the area of Romney, Denge and Walland marshes, reclaimed from the sea over a thousand years; they are a final extremity in a place of extremes.

This is a journey that Nigel Green has taken many times over the last twenty years or so. Travelling from his home in Pett Level to the east of Hastings, he has been drawn to Dungeness almost as a place of pilgrimage, as a place more gritty, more unforgiving and somehow more real than the picturesque Sussex countryside or the gaudy excesses of the seaside town. The topography around Dungeness is unique, extending from the flat marshland as a shingle peninsula covering seventy-two square kilometres, one of the largest such formations, along with Cape Canaveral, in the world. The shingle now sustains a small and slowly growing community. Originally this was comprised of wooden fisherman's huts scattered over the shingle, but they have been added to over the years by more substantial rows of bungalows and houses. Yet, despite the expansion, the strong impression is that this landscape is still untamed. The housing feels speculative and vulnerable perched on the shingle, belittled by the huge skies, wide-open spaces and the ever-present latent power of the sea.

The plans to locate a nuclear power station at Dungeness go back to 1957[1], and were from then on veiled in secrecy. Other sites, such as nearby Cuckmere Haven in Sussex and the Isle of Sheppey in north Kent, were considered, but, despite resistance from Kent County Council, the National Farmers Union and several other local agencies, Dungeness appears to have provided the least objections. The views of the local community, especially the fishermans' 'shared wisdom' and knowledge of the 'vagaries of the sea'[2], were not consulted as part of this process. For these local people, who knew of two wooden houses that were disappearing into the sea due to the shifting shingle, Dungeness was an extraordinary and inexplicable site for a nuclear power station. To this day the awkwardness of the stations' location is given a note of absurdity by the fact that hundreds of tons of shingle have to be moved by lorry each day from one side of the peninsula to the other in order to protect the stations from tidal erosion. Inevitably the building of the stations had, and continues to have, a huge impact on local people and has irredeemably altered long established patterns of life at Dungeness. And yet, strangely, in spite of the incongruity of their position and the under-standable resentment, the stations somehow feel integral now to this modern wilderness, the collision of nature and culture has produced something remarkable, an additional force of character that is both stark and magical.

Nigel Green's connection with Dungeness dates back to the early 1960s when his father worked on the commissioning of 'A' Station, the first nuclear power station to be built on the site. The station was first 'brought

1 For a more detailed account of the siting of the power stations at Dungeness, and a more comprehensive local history, see Ged Robinson (ed), *Dungeness: a unique place*, Sutton House, Iford, East Sussex, 1998.

2 Ibid, p. 18.

to criticality' in 1965, the year Green was born. From his first visits as a child with his father, and from the formative impressions of the place they created, to his more recent visits as an artist – including those after his father's death in 1999 – Green has developed an enduring fascination with the place over thirty years. He is certainly not alone in this fascination. For many years artists and writers have been attracted by the spare beauty of the landscape around Dungeness, and by its sense of geographical and cultural isolation. The place has been of particular interest for photographers, amateur and professional alike, who have long recognised its photogenic qualities, a mixture of the surreal and the commonplace to be found among the bizarre formal arrangements of wooden huts, old fishing boats, pylons and what often appears to be mutant vegetation clinging to the infertile shingle.

The artist most famously associated with Dungeness is Derek Jarman, who bought Prospect Cottage, an old weather boarded fisherman's hut there in 1986. From then until his death in 1994, he created a fantastical garden around the cottage, gathering indigenous plants such as sea kale and wild red poppies and blending them with those he introduced: herbs, lavender, cistus, as well as yucca and an enormous artichoke. Within this planting he created a loose sculptural arrangement of found objects, a kind of junk gothic of flints, driftwood, old tools and other pieces of discarded metal salvaged from the shingle. The garden inspired one of the most well known photographic responses to Dungeness in Howard Sooley's beautiful series of images that illustrate the book *Derek Jarman's Garden* published in 1995[3]. Jarman, like others, sought peace and solitude at Dungeness, but his legacy and the popularity of his garden book has created, or perhaps reinforced, one exotic impression of Dungeness as a kind of fabulous wasteland, a bohemian sanctuary at the edge of the world. This image has attracted many new visitors to the place – those both passing through and more permanent – and has, in turn, created new challenges for the older fishing community who have lived and worked there for generations.

Green is well aware that Dungeness has generated a vast and disparate body of photographic work. Over the years, as habitual visitor and image-maker, he has contributed to it himself. But when the opportunity arose to make new work for a Photoworks commission, Green had the chance to step back and reconsider his relationship to the place. He had about a year to create something altogether more concentrated and more specific than he had done before, a piece of work that would perhaps accommodate and bind together the disparate threads of personal history (including those first childhood impressions) with the ideas that have become central to his practice as an artist. In this respect his interest was not so much the romantic post-Jarman Dungeness and its evolving community or the strange shapes found on the shingle, but more the huge grey silhouette of the industrial complex that hovers in the background of Howard Sooley's photographs and in many others of Dungeness. Ironically for Green, the nuclear power stations' brutal steel and concrete structures harbour poignant memories and a sense of mystery. For him they are both a locus of identity, a specific reference point in his experience, and a more expansive site of transmutation that releases an alchemical charge into the surrounding landscape and through his own imagination. But the stations are also representative of broader cultural histories. And importantly for Green they are bound up with the legacy of modernism. Since undertaking his MA in Fine Art at the University of Brighton, during which his practice moved from painting to photography, Green has become increasingly interested in how modernist ideas have shaped social environments and the ways in which photography, itself a product of modernity, intervenes in and frames those environments.

Green's approach to Dungeness is informed by these interests: on the one hand he sees its vast architectural and technological complex as an archetypal modernist space wrenched from unbounded, 'natural' surroundings, and on the other, as a more abstract image of control. Most obviously here, the stations can be seen to enact some final monumental

3 *Derek Jarman's Garden* (with photographs by Howard Sooley), Thames and Hudson, London, 1995.

control and harnessing of the forces of nature; a kind of apotheosis for modernism's rationality and social ideals. But in terms of the scale, shape and physical presence of the stations, this control of nature has the bearing of an epic struggle from the past. As Green has suggested, 'there is something of the medieval castle or fortified citadel about the stations. They make up a self-functioning entity that represents the control of knowledge and power', whose impenetrability 'much like Kafka's castle...is also a symbol of the unknown'[4].

And yet there is an undeniable beauty here, a formidable aesthetic, and a sense of the elegiac, too, in an ideal that begins to lose its potency and fade from view. To approach Dungeness at night, as Green has done many times, is to see the power stations in this way. Twinkling on the horizon, as Derek Jarman said, 'like an ocean liner', they might well be described in terms of a sublime vision; a fabulous modernist spectacle, a shimmering city of light that is a fitting monument to the aspirations of the 1960s and to a belief in nuclear power that now hangs in the balance.

For the duration of his Photoworks com- mission, Green's visits to Dungeness became a period of intensive work that developed, broadly, through three distinctive phases. The first took the form of an orientation, a conscious coming to and gauging of the site; skirting around the complex, taking account of its extent, its various aspects and its setting in the landscape. In this early work he began to measure the brooding dominance of the stations over the land and make suggestions as to what the place may have become as a result. His sequence of bramble bushes, for example – part comical, part sinister – are the signs of a sparse but resilient vegetation but also suggest an eco-system infused with competing energies. This mini-typology is our point of entry into an alien territory. But this alienness is also at the heart of Green's fascination; the compelling idea of a place altered and unfathomable, with a life of its own. And then there is the magnetic pull of technology at the centre of this. Looking with the photographer towards the power stations in his first colour

photographs, across the boundary fences to perimeter roads, outer buildings and car parks, we feel this lure of technology, of an ordered system that, as the sun fades, we see glowing with its own energy.

The second phase of Green's work is marked by his moving into the interior of 'B' Station, where he was allowed unprecedented access by British Energy. These interior photographs are a response to the real, often awe-inspiring scale of the stations' spaces, to the blunt facts and unavoidable presence of the place. In this Green is conscious of his work as part of a modernist tradition, and especially as part of modern photography's continuing preoccupation with the machine, with industrial and technological spaces and with the work that takes place within them. Photographers such as Charles Sheeler and Albert Renger Patzsch, and their iconic photographs of industrial spaces from the 1920s and 30s, still provide a good working template for Green's approach to the interior of Dungeness 'B'. And, he would admit to employing a sense of their heroic realism in the face of human achievement on such a grand scale. There are also echoes here of the modernists' insistent connection between technology and transcendence. As Moholy Nagy said in 1922: '...the reality of our century is technology – the invention, construction and maintenance of the machine. To be a user of machines is to be of the spirit of the century. It has replaced the transcendental spiritualism of past eras.'[5] In one photograph, Green pictures the cathedral-like interior of the reactor in just these terms. It is an image of elegant formalism reminiscent of high modernist photography, but also one that aims to reflect his genuine sense of wonder on experiencing the space.

This is a consciously dramatic moment. Elsewhere Green prefers the more perfunctory descriptive qualities of colour, using a large format camera with a 5x4" negative to clearly define the intricacies of the spaces and machinery. But this painstaking documentary style is also a constant reminder that Green's response to Dungeness constitutes a record of something that in time will inevitably disappear. Dungeness 'A' station is due for

4 From the artist's preliminary notes to his Photoworks commission.

5 Quoted in, Karen Lucic, *Charles Sheeler and the cult of the machine*, Reaktion Books, London. 1991, p. 11.

decommissioning in 2006, the 'B' station sometime later, but whatever the fate of the nuclear industry, the vast scale of these interiors already acts as a symbol for the passing of an era. In time the massive machines and pipe-work will become bizarre relics, grotesquely large and overcomplicated in a miniaturised future. Even now they seem overburdened by the accumulated wisdom of an industrial age.

In this sense Green's colour photographs have a narrative aspect, we can read history in his pictures in the same way we read it in the cityscapes and industrial scenes of contemporary German photographers such as Thomas Struth and Andreas Gursky. Although in contrast to Green's work, Gursky's digitally re-constructed photographs, in particular, explore the way in which the past is overwritten by the multiple modular systems of post-industrial networks. Green looks into the past rather than the future but it is perhaps ironic that the historic modernism and dense machine tracery in his photographs of Dungeness 'B' now reminds us most of technology on a micro scale, of computer circuit boards blown out of proportion.

If Green's interior photographs of Dungeness 'B' have something of the child's wide-eyed stare about them, they also register an oppressive weight, a surfeit of detail that is almost deranged in its intensity and dumb presence. Green's third phase of work at Dungeness involved a turning away from these imposing facts, from the overbearing literal record, and a withdrawing from the site of Dungeness into another site of transmutation, the photographic darkroom. In common with his practice of recent years, Green now embarked on a process of re-imagining his work, of re-inventing it through the rigours of further editing and re-processing. And in this he enacted a bravura reversal, creating something like a photographic alter ego in his work that carries with it the duality and complexity of his response to Dungeness.

Sifting and searching through the photographs from the first two phases of his commission, he selected small details from the images, which he then subjected to harsh re-printing and chemical staining. Cut or torn from their original image and context, these works then gain another life as autonomous fragments. Like remnants of some lost industrial archive, they allow a less descriptive more poetic photographic space to emerge in Green's work.

With their rough edges and pale wash colours, these miniature fragments also reinforce the sense of the photograph as object. They appear to be reclaimed, 'found objects' that allude to the evidence of an event, clues in a broken narrative. They are like incomplete memories; highly resonant with a sense of time and place they situate the power stations as part of a less stable, more recognisably elemental landscape. Through heavily cropping his photographs in this way, Green creates a new imaginative dimension for the viewer, too. Focusing in hard on details he also reinvents the space outside the frame, 'that blind field beyond the image', as Joanna Lowry has called it, 'that becomes the focus of our investment and desire'[6] in relation to the work.

In the contrast between his large-scale colour images and these 'subtly fetishised' photographic fragments, Nigel Green's work accommodates a fundamental ambiguity. While he is sensitive to the unique environment at Dungeness, its fragility and vulnerability, and while he is aware of the damaging absurdity that led to building the stations on such an unstable site, he is also drawn to their peculiar form of grandeur, both banal and elegant, and to the supremely sophisticated levels of human endeavour they undoubtedly represent. Despite his concerns for the landscape and its history, Green's work refuses to be constrained by the entirely negative image of a malign, invasive technology that, for so many, the nuclear power stations represent. His work, as well as admitting a sense of threat and the uneasy confluence of nature and culture that runs through the place like an electric charge, recognises that the presence of the power stations has created a hybrid landscape, one that is harsh and bleak but within which a raw and undeniable beauty continues to surface.

6 Joanna Lowry, 'Time, Modernity and the Photographic Machine: the work of Nigel Green', in *Insight*, Photoworks magazine, Maidstone, July 1998, p. 12.

DUNGENESS

A VAST expanse of wild and barren
strand,
But sparsely clothed with verdure and
with flowers
In sweet confusion mingled: while there
towers
High over all the Light-house. Close at
hand
In mighty force the storms rage, as I stand
To watch the vessels scud before the gale;
And hear, of wrecks the horror-laden
tale
That thrilled impulsive hearts throughout
the land.
No spot, than this, more desolate remains,
Yet with this place, my fondest wishes
dwell,
For deeds of manly daring fling strong
chains
Of memory around it: I could tell
Of honest Truth and Love, with fewest
pains
All linked to Dungeness – Heaven bless
it well!

Joseph Castle B.A.
Coastguard chaplin
Dungeness 1887

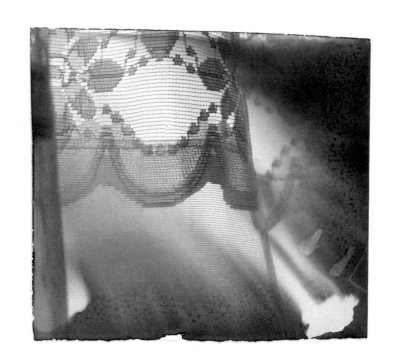

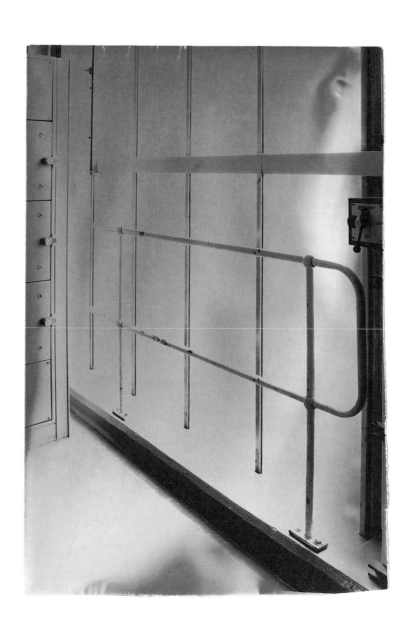

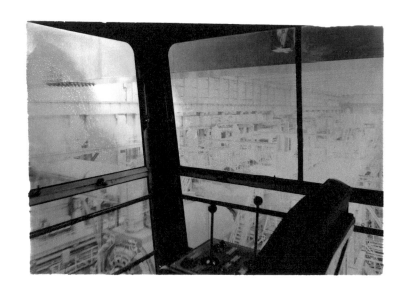

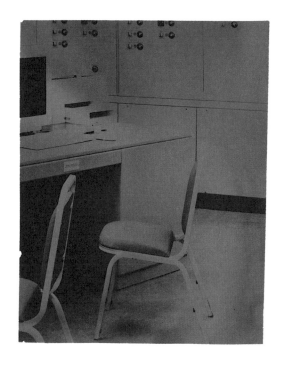

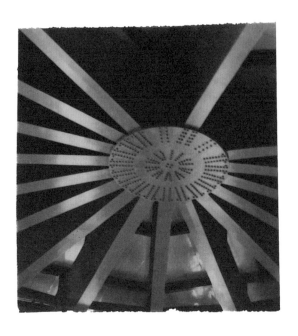

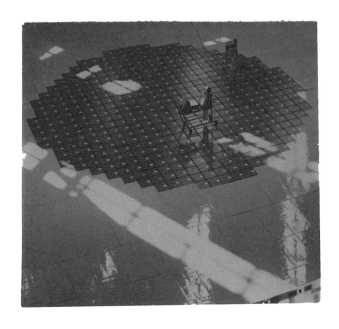

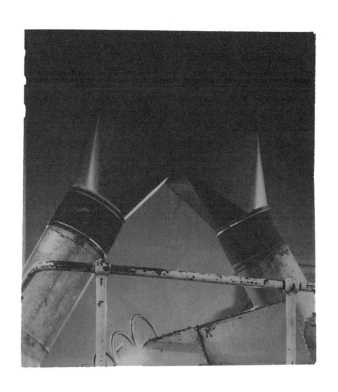

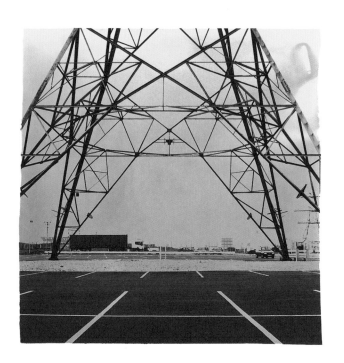

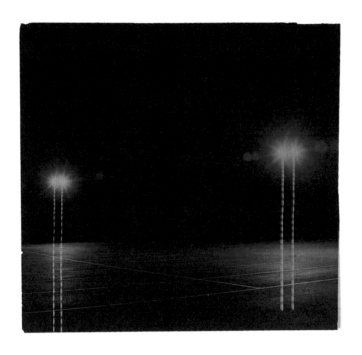

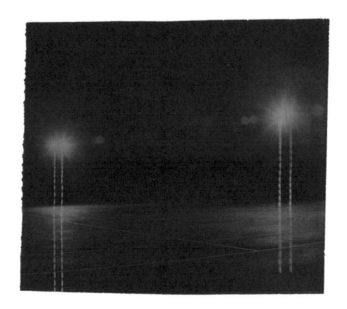

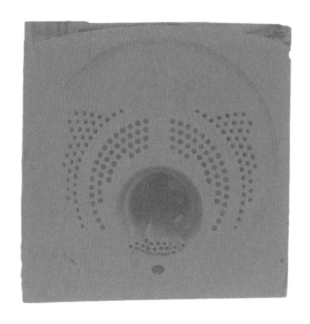

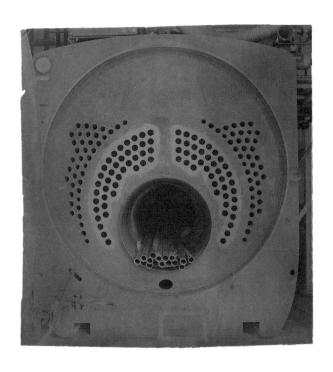 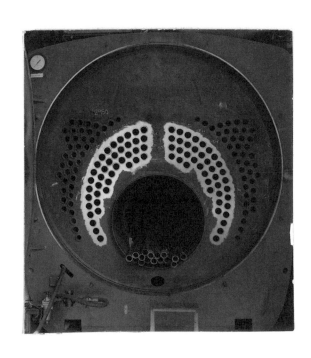

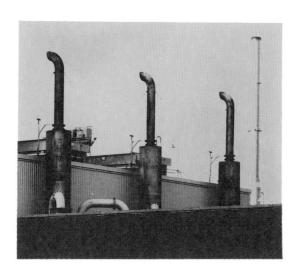

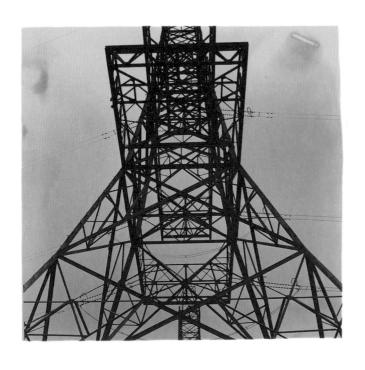 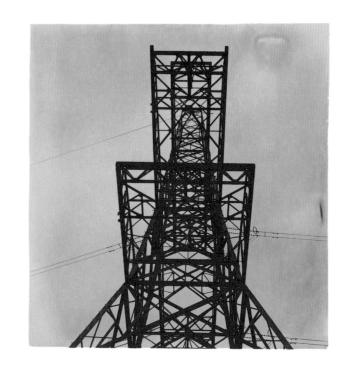

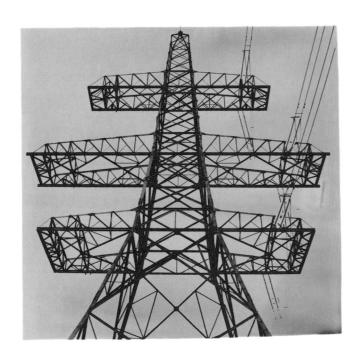 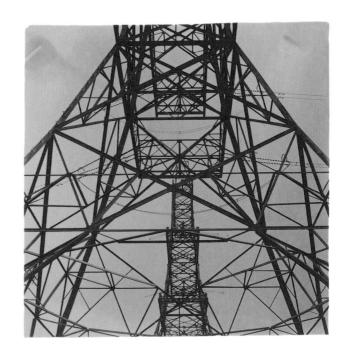

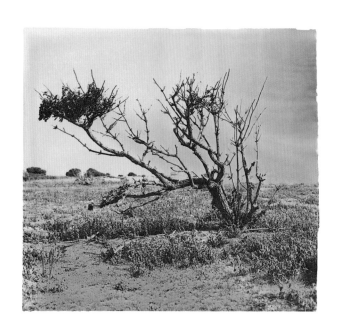

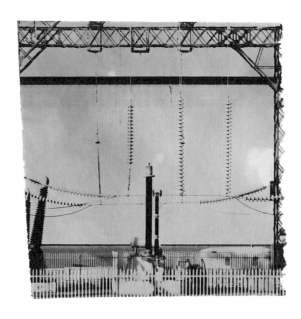

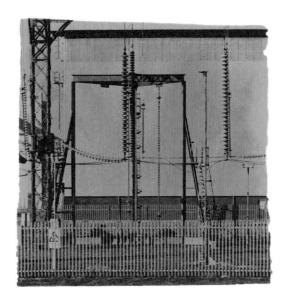

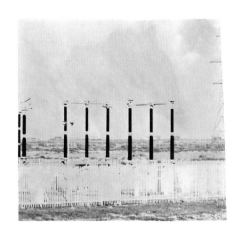

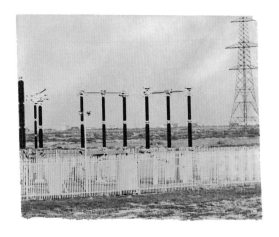

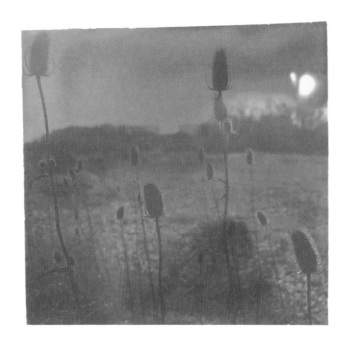

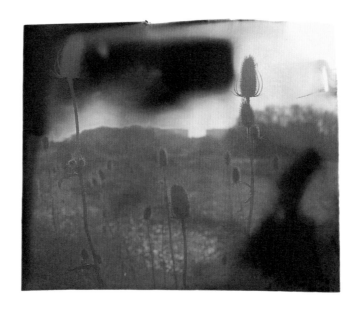

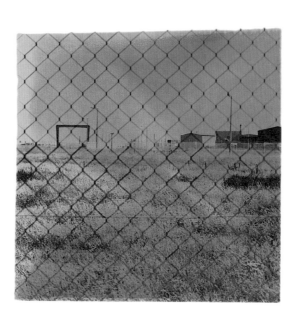

A few years ago, I was visiting the artist Brian Yale who has lived for many years in a clapboard cottage on the shingle shores of Dungeness. We were drinking tea, when, suddenly, an almighty roar rent the big summer sky. It was as if, here at the physical end of the world, for that is what Dungeness always appears to be, the Apocalypse was on Yale's timber doorstep. My immediate impression was that one of the nuclear power stations along the beach had gone the way of Chernobyl. All we could do, it seemed, was to take one last sup of tea before Armageddon, oblivion and the long wait for the Last Judgement.

The intense blast that afternoon left me a little shaken for a moment, while Brian Yale was merely bemused. The noise, he explained, was a rush of high-pressure steam released from the boiler of one of the power stations. It was simply an amplified version of the ear-splitting plumes of steam that soar from the impatient boilers of the small and perfectly formed steam locomotives of the Romney, Hythe and Dymchurch Railway that tug their train loads of holiday-makers and enthusiasts along past Yale's cottage on the last leg of their fourteen mile seaside journey along the hem of the Romney Marshes from Hythe to Dungeness.

Dungeness catches the imagination like few coastal settlements. It is not exactly a village,

and certainly not a town. It is neither a resort nor a place many people will feel particularly comfortable with. It has no pier, no amusement arcades, little or nothing in the way of rock, saucy postcards or kiss-me-quick hats. It has no hotel. It is very much its own place, a kind of wilful stage-set on the very south-easterly tip of England. It might have been made for Emma Peel (Diana Rigg) and John Steed (Patrick Macnee) to act out their adventures in ABC's cult Sixties TV series *The Avengers*. Its appearance, though, is more accident than design. Here is a settlement – once an island cut off by flood waters – composed of Europe's largest shingle beach, timber cabins, railway carriage homes, a brace of lighthouses, a miniature main-line public railway, a tiny commercial fishing fleet, acres of marsh, rare birds, moths, and plants, an airport pretty much of its own, views of France on clear days, regiments of electricity pylons marching towards a flat horizon, and two thumping great power stations that, should their reactors crack, would see them and south-east England either vanish, or else remain toxic for thousands of years to come.

I cannot say that I love Dungeness, yet, like Brian Yale, and like the late artist, writer and film-maker, Derek Jarman, who came to live here and to plant an Alice-in-Wonderland

garden before he died in 1994, I am one of many people attracted to this curious Kentish outpost, like the larvae of the local White Spot Moth is to the rare Nottingham Catchfly that flowers here in the shingle dunes.

What Dungeness has that is special, aside from its very particular wildlife and all but fictional landscape, is the sense that it has remained so relatively unchanged, escaping the prissy tedium of the rest of south east England, the political lie that is cool New Britain, the convention by which all of the south east must become one giant, government-approved suburb. Here, it feels as if planning laws have never existed. There are no polite and bricky executive cul-de-sacs, no banal shopping malls, no air-conditioned, fluorescent-lit office blocks, no golf courses, neat kerbstones, yellow lines, speed bumps, no traffic wardens or CCTV cameras, no bored and boring yoof lurking under medieval hoods on street corners. Physically, socially and emotionally, Dungeness is a very long way from Middle England.

But it is not exactly bohemia either. Dungeness is more the home of a certain breed of bloody-minded Englishman and woman – adventurers, sailors, crofters, poachers, smugglers – who have the blood of John Bull as well as Hereward the Wake, Robin Hood, the archers of Agincourt, John Bunyan,

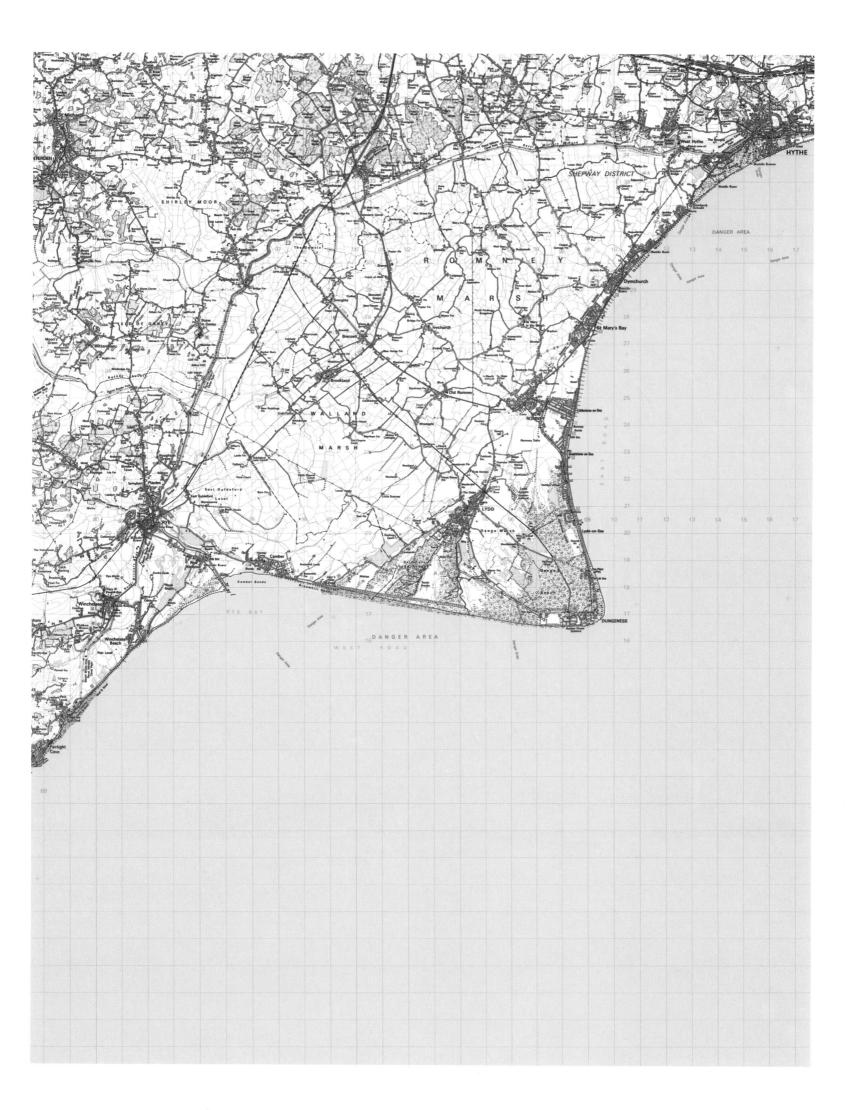

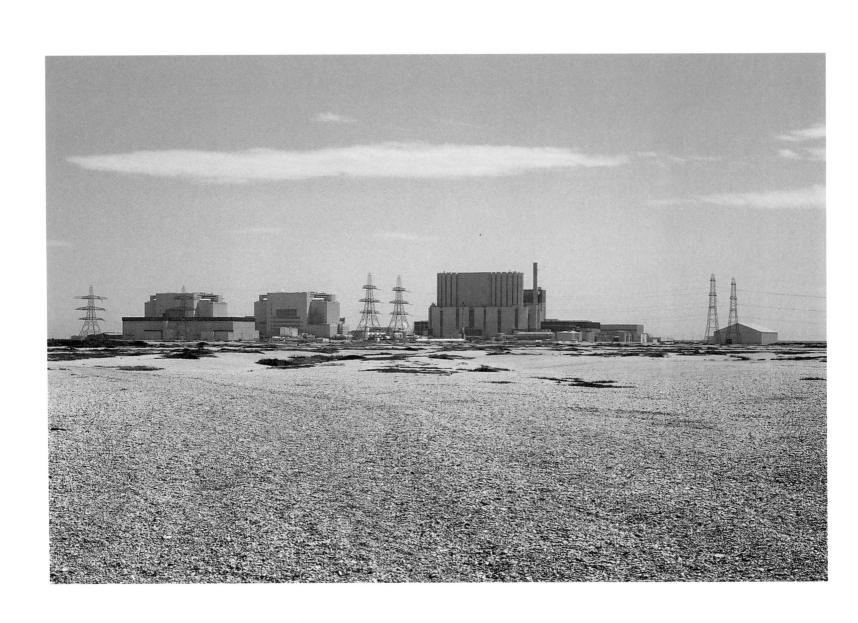

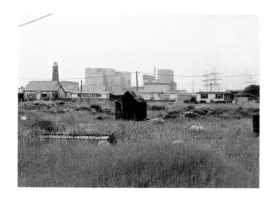
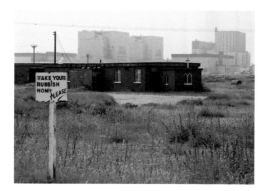
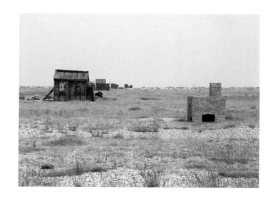

William Cobbett, and even William Blake coursing through their veins. Most of the families who have settled here are as rooted to the place as the yellow horned poppies, viper's bugloss, marsh fern and saw hedge that adorn the shingle beach and cabin gardens. Plant life here is hardy and enduring. It has to be. And, yet, it seems miraculous that so many plants do thrive here, and right on the rough sea's edge, too, like sea campion, thrift, stonecrop and edible sea kale.

Dungeness broods at the very edge of the map of England. It is a natural dead end. No one passes through accidentally. You have to want to come here, but when you do the approaches are all special. The most surreal is by the Romney, Hythe and Dymchurch Railway. I last rode on the railway a few years ago to travel with the schoolchildren who go to and from the Southlands Community comprehensive school at New Romney. The railway beat rival bids from local bus and coach companies for the school traffic. The journey itself is a remarkable experience. Day in, day out during term time fogs, storms, ice and snow, children get to school on time travelling between marsh and bungalows by the railway's miniature express trains. Mostly, these are hauled by diesels, but, especially when the weather is foul, the school run will be headed

proudly by 'Green Goddess', 'Typhoon', 'Winston Churchill', 'Dr Syn' or 'Northern Chief'. Sometimes, in winter, the school trains are double-headed by a pair of steam locos equipped with snow-ploughs. You might think Kent a county perenially summer, all darting swifts and cream teas, yet on the downs as on the east coast, winter can cut up rough, and bitingly cold.

A ride on the RH&DR in the depths of winter is a glorious experience for those imbued with the spirit of Captains Scott and Oates. The railway's history is equally adventurous. Created in the 1920s, it was the dream of two, playboy millionaire racing drivers and railway enthusiasts, Captain Howey and Count Zborowski. Before the railway was opened, sadly, Count Louis Zborowski, of *Chitty Chitty Bang Bang* fame, was killed driving in the Italian Grand Prix at Monza. Captain J E Howey saw the line through to completion in 1927. The locomotives were one-third scale models of the latest London and North Eastern Railway A1 Pacifics designed by Sir Nigel Gresley. 'Green Goddess' and 'Northern Chief' were the first. Designed by Henry Greely, they were built by Davey Paxman and Co, Colchester, in 1925. Both continue to run at 25mph – officially – a scale speed of 75mph, on their narrow tracks from Hythe to Dungeness along past Long Boat

Cottage, home of Edith Nisbet, author of *The Railway Children*.

The railway was closed to the public during the Second World War. The world's smallest armoured train, pulled by the 4-8-2 'Hercules', was built for the line, which was, of course, in the front line of German attack. Equipped with Lewis guns and a Boyes anti-tank rifle, it was credited with one 'kill'. It seems that the Luftwaffe pilot in question misjudged the scale of the railway and dived too low into the attack.

Rebuilt with the aid of Italian prisoners of war, the railway was refurbished in two sections. The second, from New Romney to Dungeness, was officially opened in 1947 by Stan Laurel and Oliver Hardy. The great Hollywood comedians were appearing at the London Palladium that spring. They larked about happily for the newsreel cameras before the train was driven through a fake wall – another fine mess – and off to Dungeness and back with lunch at The Jolly Fisherman at Greatstone-on-Sea on the way.

It seems appropriate that such an unlikely line should take its passengers down the coast to the equally unlikely and unexpected Dungeness, where they stand for a while in the formidable shadow of power stations 'A' and 'B', taking photographs, then climbing the 169 stairs of the old Dungeness lighthouse.

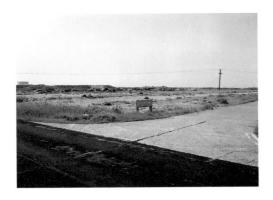 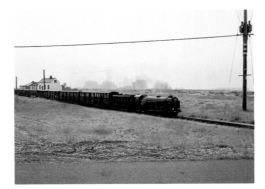 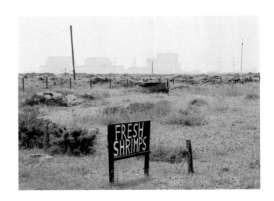

Later they wolf down portions of locally caught and fried cod and chips, guzzle tea and Coke, sandwiches and cakes at the station café before steaming back, between sheep and bungalows, to Hythe and the restless car ride home.

An alternative way of getting to Dungeness, if you have the means, is to fly in to Lydd Airport, which sits quietly, utterly alone, between Denge and Walland Marshes. There is one regular service here, by one of LyddAir's 16-seat Britten-Norman Trislanders, to Le Touquet. Le Touquet, or *Paris-Plage*, built largely by the British, but where, today, smart Parisians come to disport themselves, play golf and dine finely, is in utter contrast to the more fish'n'chips Dungeness. I flew from Lydd as a boy in the one-time Silver City Airways Bristol 170 Mk2 Superfreighters. These whale-like planes, borne up by 2,000hp Hercules engines, carried three cars and fifteen passengers at a time to Le Touquet, cruising at 165kts at between 1,000 and 1,500-ft. It seemed, if only you could have opened one of the aircrafts's big oval windows, that you could have brushed the waves with your hand. In its heyday King Faisal of Iraq, Humphrey Bogart, Diana Dors and the Queen Mum all flew from Lydd. When the Trislander climbs away today – each seat is a window seat – you get a glorious view of Dungeness before turning for France, and lunch.

A third way to Dungeness is by car, from Rye along the south coast. Quite suddenly, the car points east from teashop, bookshop, charity shop Rye, along a plain as flat as a sheet of paper. You run on down to Camber Sands, a gloriously unreconstructed holiday camp resort where, it seems, the clocks stopped in 1959. Here, lobster-skinned bathers munch sandy sandwiches behind wind-breaks and old men really do roll up their trousers for a paddle with knotted handkerchiefs on their heads. Beyond Camber, the narrow road winds past Jury's Gap Sewer – a Ministry of Defence 'Danger Area' – then Pigwell, the southern outreaches of low-lying Lydd, along Denge Marsh and under the gigantic steel arms of a legion of electricity pylons, to the east coast just above Dungeness proper. This is a sensationally bleak ride at the fag end of the year. It can look as if the power stations really have exploded and you are making your way through the devastation of a nuclear winter. In summer, though, the plants begin to shine through the encroaching shingle, and the sky, though criss-crossed with a cat's cradle of crackling power cables, is alive with birds.

This is a wonderful place to see birds. I have never made list of all those I have seen, but when I think of Dungeness, I remember oyster catchers and ringed plovers, redshanks and lapwings. There have been reed buntings, sedge warblers, corn buntings and yellow wagtails, too, alongside the black-headed gulls and common terns that breed here. And ducks of all kinds – mallards, gadwalls, shovellers – oh, and both little and great crested grebes. And, hunting in summer, between swans, by day, and small eared owls, by night, are merlins and hen harriers. If you stand long enough at particular times of year – particularly in the local RSPB sanctuary founded here, the first of its kind, in 1931 – you will see countless breeds of birds as they fly in and out of the British Isles in search of sun and places to feed well and lay their eggs in peace. At least one breed – the black redstart – makes its nest in the concrete brows of the power station.

The shingle is never dead, no matter how Moon or Mars-like its surface can seem. Staying here overnight at different times of year, I have witnessed the secret ministries of foxes, badgers, stoats and weasels and seen brown hares racing at sunset across the marsh. I have listened to choirs of marsh frogs and dared to hold a glistening medicinal leech in the palm of my hand; these thrive here. As do the fish and shrimp that sport in the unnatural thermal pools bubbling around the hot water outlets of the power stations. They still fish at Dungeness. In winter, for cod, whiting and dab; in summer, for pout, dab, bass, sole and eels. Dungeness

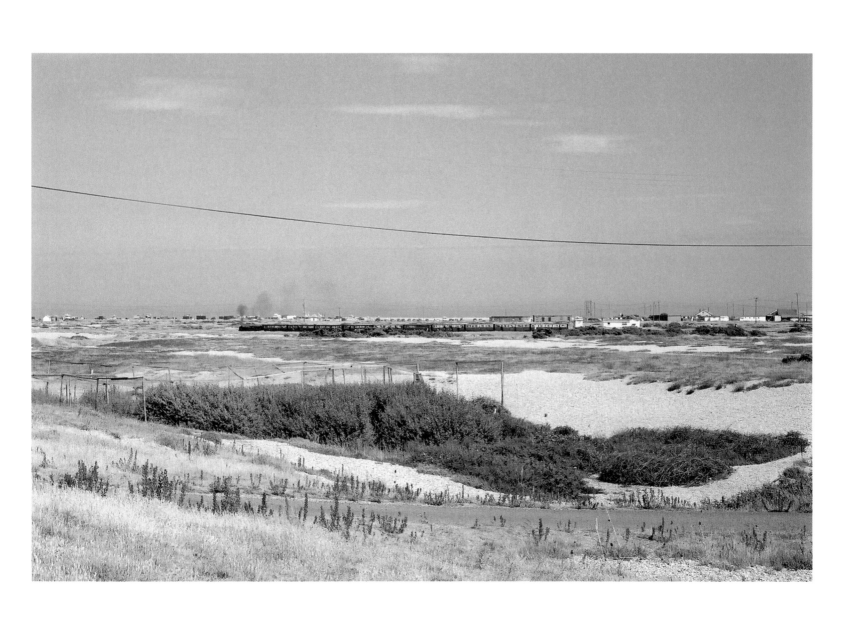

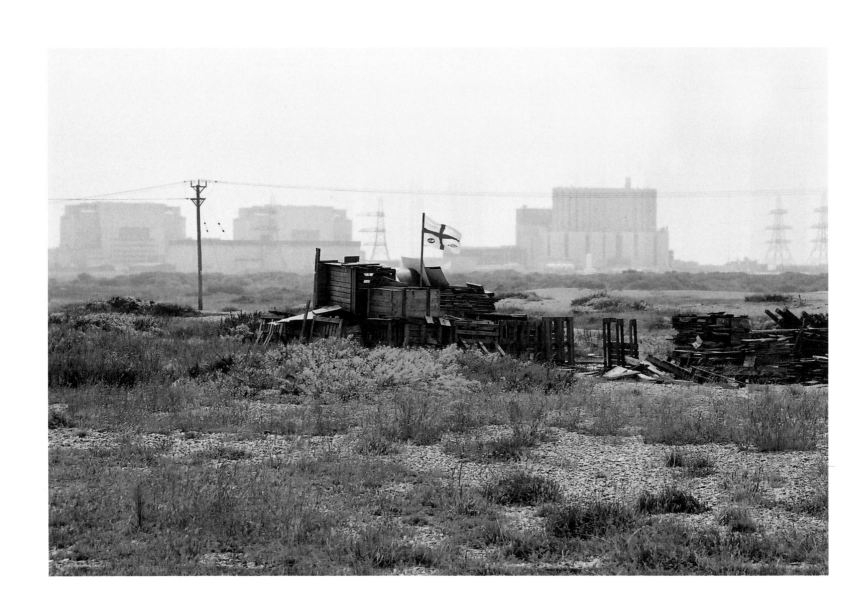

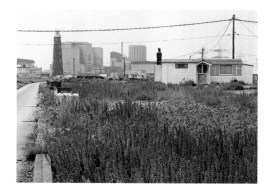 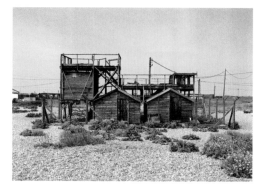 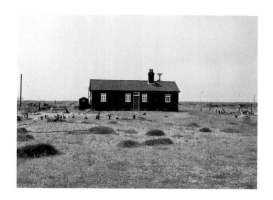

Fish on Battery Road offers visitors and locals fresh cod and cockles, scallop and salmon. The fishing boats are chained to the ever-shifting shingle. It seems a miracle they stay put.

If Dungeness feels cut off, this is exactly what its fate was to have been during threats of invasion. At the time of the fright of the Napoleonic wars, a canal was dug right around Walland and Romney marshes, from Winchelsea and Rye to Hythe. If Napoleon's Grand Army had made it past the Royal Navy across the Channel, and beyond the guns of the Martello towers that still line England's east coast, it would have landed here. As it marched towards London, it would have been stalled by the Royal Military Canal. From the other side of the water, our boys, would have pounded Johnny French into submission. Or, so the theory went. Luckily, the efficacy of the Royal Military Canal was tested neither in Napoleon's heyday nor in Hitler's. The Fuhrer's much vaunted Operation Seelowe (Sea Lion) was, fortunately, and with the help of RAF Fighter Command battling over Kent in the summer of 1940, little more than a damp squib.

Today the 28 miles of canal, built between 1804 and 1806, acts as a flood barrier for the marshes and as a wildlife retreat. You can walk along towpaths from one end to the other, accompanied not by French hussars or black-clad troopers of the Waffen-SS, but by the sudden flash of kingfishers and the peerless aerobatics of the Ruddy Darter and Hairy Hawker dragonflies re-enacting miniature Battle of Britain dogfights at low altitude across the immense Kentish sky.

Dungeness does not belong to the world outside. It offers the elements in all their stark, rough glory. It offers nothing to dedicated suburbanites, and a great deal to those who love out of the way places with a life very much their own. I keep saying I hope it survives. If encroaching Middle England and its train of tedium fails to get Dungeness, then perhaps one of the trains that run from Dungeness 'A' to Sellafield might. Only last summer, a lorry crashed into one of the trains carrying spent fuel rods from Dungeness 'A' to Sellafield's thermal oxide reprocessing plant. This was at the unmanned level crossing at Brenzett that connects with the passenger line to Rye in one direction, Ashford in the other. Luckily there was no further mishap, yet no one feels a hundred per cent safe as these trains continue to lumber through Kent laden with nuclear waste.

One day, perhaps, the power stations will be replaced by wind farms. Thousands of wind turbines might sprout from shingle and marshes, humming like unearthly insects as they feed power into an insatiable national grid.

If built, they would be no more, no less bizarre here than the existing nuclear power stations. The fishing fleet would continue to put out at night. Artists, like Brian Yale, would continue to paint. Fish and shrimp might miss the warm power-station waters, but birds would continue to enter and leave Britain via Dungeness and the marshes. The miniature express trains of the RH&DR would steam in and out of Dungeness station along past Derek Jarman's garden. Pints would still be pulled and karaoke sung at the Britannia. Local people would still choose to live in clapboard cottages and old railway carriages. The striking modern lighthouse would continue to warn shipping away from this treacherous coast. Best of all, those who like their world neat, tidy and sub-topian, would never in the half-life of an isotope choose to live next to a humming electric wind farm.

Strangely, the nuclear power stations, and the fear they instil in outsiders, keeps Dungeness free from an invasion of the obvious, from an ever growing world in which anywhere, anyone different is considered not just off, but seditious and all but evil. Once a place for lawless smugglers, like Dr Syn, local priest by day, outlaw by night, Dungeness remains, at least for now, happily beyond the pale, beneath the salt, and, at any time of the year, all but under the shingle.

TO THE MEMORY OF MY FATHER, JOHN GREEN

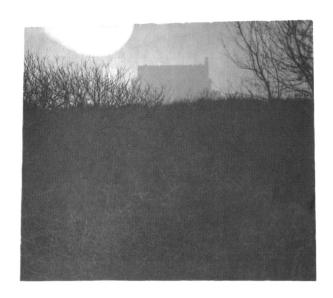

FIRST PUBLISHED IN 2003 BY PHOTOWORKS
THE DEPOT, 100 NORTH ROAD, BRIGHTON, BN1 1YE
T: 01273 607500
F: 01273 607555
E: INFO@PHOTOWORKSUK.ORG
WWW.PHOTOWORKSUK.ORG

PUBLISHED FOLLOWING AN EXHIBITION AT THE SASSOON GALLERY
FOLKESTONE LIBRARY, 2 GRACE HILL
FOLKESTONE, KENT CT20 1HD
26 JULY - 13 SEPTEMBER 2003

EDITED BY DAVID CHANDLER
DESIGNED BY SMITH
PRINTED IN GREAT BRITAIN BY DEXTER GRAPHICS LTD

BRITISH LIBRARY CATALOGUING-IN-PUBLICATION DATA. A CATALOGUE RECORD FOR THIS BOOK IS
AVAILABLE FROM THE BRITISH LIBRARY.

ISBN 1-903796-07-5

DISTRIBUTED BY CORNERHOUSE PUBLICATIONS
70 OXFORD STREET, MANCHESTER, M1 5NH
T: 0161 200 1503
F: 0161 200 1504
E: PUBLICATIONS@CORNERHOUSE.ORG

PHOTOWORKS PROMOTES PHOTOGRAPHY WITHIN THE SOUTH EAST OF ENGLAND, COMMISSIONING AND PRODUCING
NEW WORK OVER FOUR MAIN AREAS OF ACTIVITY: EXHIBITIONS, PUBLICATIONS, RESEARCH AND EDUCATION
INITIATIVES. PHOTOWORKS IS SUPPORTED BY ARTS COUNCIL ENGLAND SOUTH EAST.

DUNGENESS: PHOTOGRAPHS BY NIGEL GREEN IS A PHOTOWORKS PROJECT, PRODUCED IN ASSOCIATION WITH
BRITISH ENERGY AND SUPPORTED BY ARTS COUNCIL ENGLAND AND KENT COUNTY COUNCIL.